D1150894

BAINTE DEN STOC

WITHDRAWN FROM
DÚN LAOGHAIRE-RATHDOWN COUNTY
LIBRARY STOCK

COROT
TO MONET

FRENCH LANDSCAPE PAINTING

THE NATIONAL GALLERY

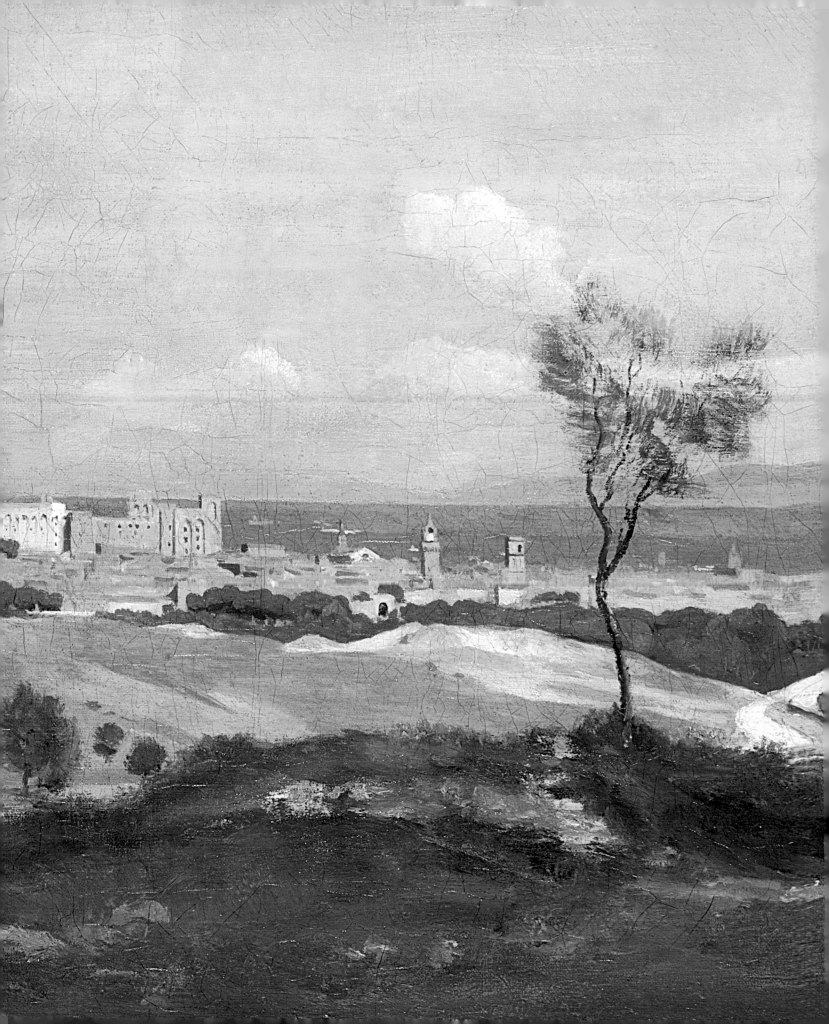

NATIONAL GALLERY COMPANY, LONDON
DISTRIBUTED BY YALE UNIVERSITY PRESS

BAINTE DEN STOC

WITHDRAWN FROM
DÚN LAOGHAIRE-RATHDOWN COUNTY
LIBRARY STOCK

COROT TO MONET

FRENCH LANDSCAPE PAINTING

THE NATIONAL GALLERY

© 2009 National Gallery Company Limited.

Reprinted 2009

The Authors have asserted their rights under the Copyright, Designs and Patents Act, 1988, to be identified as Authors of this work.

All rights reserved. No part of this publication may be transmitted in any form or by any means, electronic or mechanical, including photocopy, recording, or any storage and retrieval system, without prior permission in writing from the publisher.

First published in Great Britain in 2009 by

National Gallery Company Limited

St Vincent House

30 Orange Street

London WC2H 7HH

www.nationalgallery.co.uk

ISBN 978 1 85709 450 3

525560

British Library Cataloguing-in-Publication Data
A catalogue record is available from the British Library.
Library of Congress Control Number: 2008937289

Publisher Louise Rice
Project Editor Jan Green
Picture Researcher Suzanne Bosman
Production Jane Hyne and Penny Le Tissier
Designer Joe Ewart for Society

Colour reproduction by D L Interactive UK
Printed in Hong Kong by Printing Express

All measurements give height before width

Contributors
SH Sarah Herring
AM Antonio Mazzotta

Front cover: **Jean-Baptiste-Camille COROT**, *The Roman Campagna, with the Claudian Aqueduct* (detail, plate 7)

Frontispiece: **Jean-Baptiste-Camille COROT**, *Avignon from the West* (detail, plate 8)

Page 6: **Narcisse-Virgilio DIAZ DE LA PEÑA**, *Sunny Days in the Forest* (detail, plate 23)

All photographs © The National Gallery 2009
Thanks are also due to Astrid Athen, Tom Patterson and Rachael Fenton from the Photographic Department of the National Gallery for additional photography.

CONTENTS

PAINTED STOCK

WITHDRAWN FROM
DUN LAOGHAIRE-RATHDOWN COUNTY
LIBRARY STOCK

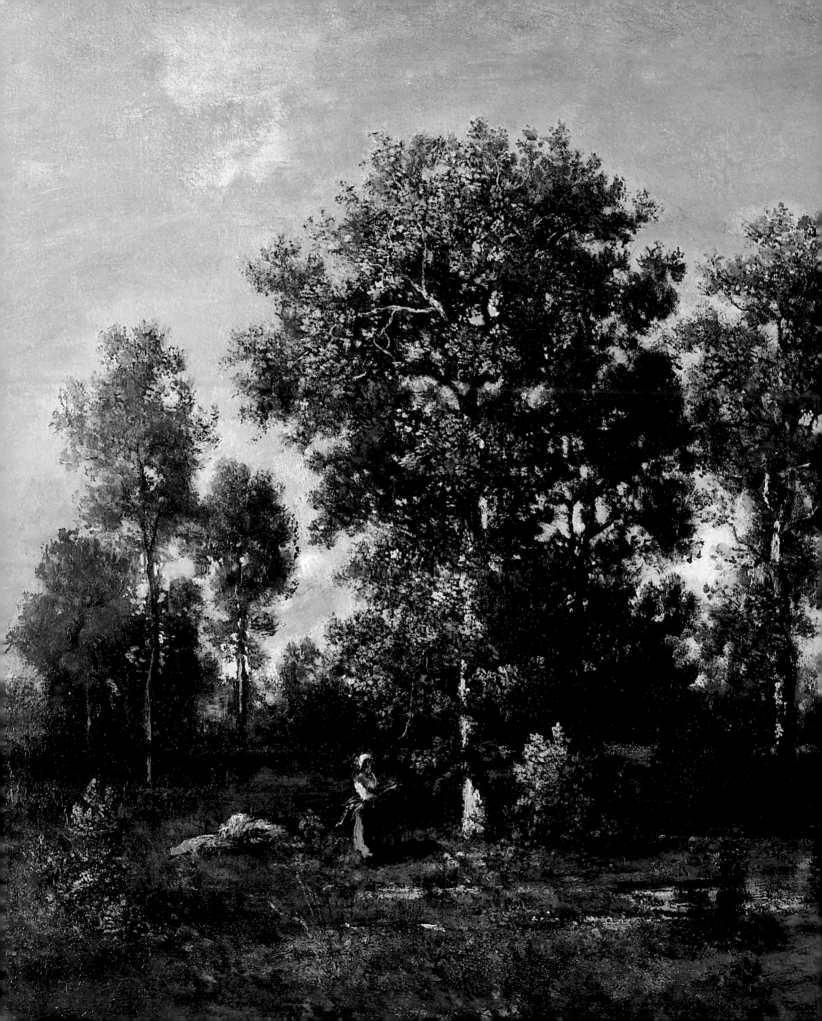

Introduction

In an earlier book in this series, *Manet to Picasso*, Christopher Riopelle remarked on the present-day phenomenal popularity of the paintings of the Impressionists and their successors. But, as he relates, the thronging crowds were not foreseen by those in charge of the Gallery a century ago, who considered Impressionist paintings, with their bravura brushwork and radical colour, unsuitable for hanging in a Gallery devoted to the Old Masters. In charting the not always smooth history of the acquisition of these paintings he touches on many points, but most strikingly he writes that it was above all private collectors who led the way in their appreciation, and to whom the Gallery was indebted in its own initial tentative forays into this area.

A similar story can be told about the Gallery's collection of earlier nineteenth-century landscapes. The Impressionist painters were the heirs of a landscape tradition which reaches back into at least the late eighteenth century. And their immediate forebears, painters of the Barbizon School, whose naturalism grew out of the late eighteenth-century tradition of sketching out of doors, were to exert a major influence on artists such as Monet and Renoir. Barbizon landscapes, intimate, and in many cases small, corners of nature, did not arouse the same controversy as Impressionist views, but perhaps it was their very size and intimacy, the antipathy to the grand tradition of historical landscape, which can explain why the Gallery was nearly as late in starting to collect works by Corot, Diaz, Daubigny and Rousseau as it was in acquiring those of Manet, Monet, Renoir and Degas. By contrast, Barbizon paintings were extraordinarily popular among British (and indeed European and American) private collectors in the later nineteenth century. These were, for the most part, businessmen; those who led what was described in the press as 'the strenuous life'. The pastoral, contemplative nature of many of these works obviously served as an antidote to their hectic occupations. It was from these private collections that the Gallery acquired its first French nineteenth-century landscapes – sometimes the very same collections which were providing such a rich source of Impressionist paintings.

At the beginning of the twentieth century the National Gallery's foreign nineteenth-century collection included paintings such as Rosa Bonheur's *The Horse Fair* (1855) and Delaroche's *The Execution of Lady Jane Grey* (1833). Still considered 'modern', they were hung in the Tate Gallery, and in 1905 they were joined there by Boudin's *The Harbour of Trouville*, bought with Frank Rutter's French Impressionist Fund (a public subscription set up to buy an Impressionist painting for the collection). The first choice had been Monet's *Lavacourt under Snow* but the Gallery's constitution prevented it from

acquiring paintings by living artists; fortunately, the Monet was to enter the collection later as part of the Hugh Lane bequest. In 1906 the first work by Narcisse Diaz, *Sunny Days in the Forest* was presented by Charles Hartree, followed in 1907 by the first Corot to enter the collection, *Marsh at Arleux*. This late work of 1871, dating from the artist's stay in northern France to escape the Franco-Prussian war, was bequeathed by Edwin Edwards, a friend and patron of the painter Henri Fantin-Latour. These two works paved the way for the loan, that same year, of a number of Barbizon paintings from the collection of George Salting (1835–1909), who was to bequeath his wide-ranging collection of not just French, but also British, Dutch and Italian paintings to the Gallery in 1910. Salting (1835–1909), one of the greatest collectors of the time, lived in just two rooms above the Thatched House Club in St James's. His was a life of legendary simplicity of habits which bordered on miserliness; famously, being unable to find a coin on his person, he once gave a penny bun as a tip to a porter from Christie's. He was also a great haggler over price, delighting in spending whole afternoons at a time at dealers in Bond Street, arguing until he got the bargain he wanted. Unusual among the collectors discussed here, he came to the Barbizon School quite late in life, but in around 1906–8 he bought a group of paintings from the dealer Agnew's, most of them from a huge and extremely important collection of paintings by nineteenth-century French and Dutch artists, purchased by Agnew's in 1906 from Alexander Young (1828–1907). Scottish by birth, but for many years head of the accountancy firm of Turquand, Young and Co in London, Young was a famously discerning collector, and there were calls in the press for public galleries, including the National Gallery, to seize the opportunity of acquiring his pictures. In the event Agnew's chose to sell off two-thirds of the collection privately to institutions or individuals such as Salting, and the remaining third in a great and glorious public sale at Christie's in June and July 1910 ('Never before in an English sale-room have twenty Corots been consecutively sold'). The Gallery bought neither from Agnew's nor from the sale itself, but was lucky to benefit from Salting's purchases, which included two paintings by Daubigny, two by Diaz, and five paintings by Corot – all late works and including the epitome of Corot's mature elegiac style, *The Leaning Tree Trunk*.

The year of Salting's bequest, 1910, also signalled the return of other 'modern' paintings from the Tate to Trafalgar Square to join the steadily growing group of nineteenth-century landscapes. A further work was added in 1912 when a group of friends of the celebrated Dutch collector and major donor to the Rijksmuseum in Amsterdam, J.C.J. Drucker (1862–1944), presented Daubigny's *St Paul's from the Surrey Side*.

Salting's bequest was unanimously welcomed by the Gallery, but this was not the case in 1913 when the Irish dealer and collector Sir Hugh Lane (1875–1915) offered to lend his personal collection of 39 pictures, including works by Barbizon painters as well as Manet, Monet and Degas. Lane had bequeathed these to the Gallery in his will, but the bequest was thrown into doubt by his unexpected death on the liner *Lusitania*, sunk by a German U-boat in 1915,

and the discovery of a controversial unsigned codicil to his will leaving the pictures instead to Dublin. (After many years of dispute the collections, while legally the property of the National Gallery, are now divided between London and the Dublin City Gallery The Hugh Lane). The codicil that Lane added to his will just prior to his death was the result of the less than enthusiastic response on the part of the National Gallery's trustees (who decided that only 15 were worthy of acceptance), of which the most famous was Lord Redesdale's; in a memorandum to the Board he wrote: 'Among the 15 pictures of which the Trustees have accepted the loan there are a few pleasing examples...but in my judgement not even one of these could stand the test of being shown with the old masterpieces. It was not for such as these that the National Gallery was originally built...'. It was not just the Impressionist paintings which alarmed the trustees although a number, such as Renoir's *Umbrellas* and Monet's *Lavacourt under Snow* sent ripples of indignation; a substantial portion of the bequest was made up of works by the Barbizon painters, including Corot, Courbet, Daubigny and Diaz, and not all of these found favour either. As with Monet and Renoir the Trustees were nervous when faced with works by unfamiliar artists: Courbet was not yet represented in the collection, and none of his paintings found favour. For the same reason the Daubigny, an uncharacteristic portrait of the painter and caricaturist Honoré Daumier, sat uncomfortably with the serene river views with which everyone was now familiar from the Salting pictures. There were also some questionable judgements; the first figure painting by Corot to enter the collection was held up, notably by D.S.MacColl, then Keeper of the Wallace Collection, as the epitome of charm, but is now considered to be by a follower.

Many of Lane's earlier nineteenth-century paintings, however, were of extreme importance. Like Salting's, they had also come from another celebrated private collection; if Salting had 'cherry-picked' from the rich collection of Alexander Young, then Lane had similarly benefited from that of Young's greatest competitor in the field, the railway magnate James Staats Forbes (1823–1904). Forbes had made a lucrative career out of rescuing failing railways, including the London, Chatham and Dover Railway Co, the Hull and Barnsley Line, the Whitechapel and Bow Railway and the Regent's Canal City and Docks Railway. But he still found time to build up a truly vast collection, over 4000 items in total, which was divided between, or perhaps more accurately, crammed into his house in Chelsea and his rooms in Victoria Station. 'Paintings everywhere, from the corridor on the ground floor right up to the top floor, paintings in the dining room and the bedroom, and up the stairs, and in the actual art room, paintings from floor to ceiling, paintings stacked in rows of ten or twelve behind one another on the floor, because there was no room for them on the walls.' It was said that he would not miss a hundred or so Corots from his collection. When Forbes died in 1904 his collection was sold off piecemeal. If the National Gallery did not take advantage of its dispersal, Lane certainly did, arranging for a portion to travel to Dublin for exhibition, and acquiring works both for Dublin (including nine Corots and Degas's *Woman with a White Headdress*) and for himself. Eight of the paintings in Lane's bequest come

from Forbes's collection, including all three Corots and a Diaz. All of the Corots which had come from Young via Salting date from the artist's mature years, when he had developed his characteristic repertory of imaginary landscapes imbued with *sfumato*. Young's preference for Corot's late works was a feature of other collectors of the period in Britain. However, Forbes's taste extended beyond Corot's late landscapes to encompass his early work, and one of the three Corots was his beautiful *Avignon from the West*, an early view characterised by clarity of style and light. It was the first such work to enter the collection.

Another collector with a predilection for Corot's early work was Edgar Degas, whose personal collection came as a revelation when it was put up for public sale in 1918 after his death the previous year. Few people had glimpsed the extent and quality of the treasures stashed away in the apartment where Degas lived as a recluse at the end of his life. Hitherto the Gallery's collecting of nineteenth-century landscapes was restricted to accepting gifts and bequests; the Degas sale marked the point when the National Gallery actively began to seek out pictures for its modern collection. Armed with a special grant from the government and with the war still raging, the then director, Sir Charles Holmes, journeyed to Paris and, against a backdrop of cannon fire bid for, and won, thirteen paintings. Among them were paintings by Manet and Gauguin, Ingres and Delacroix, and a jewel of a Corot from his very first trip to Italy in the 1820s, *Landscape in the Roman Campagna*. The Gallery also bought a fluid early oil sketch by Théodore Rousseau, *The Valley of Saint-Vincent*, which Degas, eyesight failing, had mistaken for a Corot when he had bought it while standing at the back of a sale room. On discovering his mistake, he still elected to keep the painting, recognising its quality and importance.

In 1914 a report by Lord Curzon, a Trustee, recommended that the Tate's collections should be extended to include not only historic British painting but also modern foreign painting. This swept away many of the ambiguities in the National Gallery's collecting policy, as well as the ban on acquiring work by living artists, and in 1926 King George V officially opened the National Gallery of Modern Foreign Art at Millbank, built with funds provided by the art dealer, Lord Duveen. As a result all the modern foreign paintings acquired up to this point by the National Gallery, including those from the Salting and Lane bequests and the purchases from the Degas sale, were transferred to Millbank, where they remained until the 1950s, when the Tate became independent of the National. During this period pictures by the Barbizon painters continued to enter the collection, many as gifts and bequests. The MP Pandeli Ralli (1845–1928) bequeathed two paintings by Daubigny in 1928, *Landscape with Cattle* and *View on the Oise*; the latter had originally come from the Forbes collection. A late poetic landscape by Théodore Rousseau was presented in 1947 by Mrs Julian Lousada. The Helena and Kenneth Levy bequest in 1990 demonstrates the continued interest of private collectors in both Barbizon and Impressionist paintings, featuring, among other paintings, Corot's *Landscape at Arleux-du-Nord* and Monet's *Museum*

at Le Havre. But the Gallery also continued the pattern of purchase begun at the Degas sales, including in 1923 a rare equestrian portrait by Corot, *Monsieur Pivot*, and in 1977 a luminous scene from Corot's painting campaigns in the Morvan region of Burgundy, *Peasants under the Trees at Dawn*. The representation of Corot was further enhanced in 1997 by the loan of his great decorative scheme painted for fellow artist Alexandre Gabriel Decamps, *The Four Times of the Day*, from the Loyd Collection.

In recent years the National Gallery has sought to complete the story of landscape painting in the nineteenth century by focusing its attention on artists working in the open air at the end of the eighteenth and the beginning of the nineteenth centuries, and particularly those who travelled from all over Europe to Italy to capture its unique blend of architecture, scenery and quality of light. In 1993 the Gallery bought one of Thomas Jones's seminal oil sketches, the tiny, almost postcard-sized *A Wall in Naples*, painted during his stay in that city in 1782, followed in 1996 by an oil sketch by the Belgian artist Simon Denis, *Sunset in the Roman Campagna*. In 1999 the collection was greatly augmented by the loan of the Gere collection of oil sketches, formed from the 1950s, with a marvellously discriminating eye, by John and Charlotte Gere. This collection of small and intimate sketches painted in the open air as part of an artist's training now sets the standard for what public institutions aspire to collect. In the same year, as a direct result of the Gere loan, Kate de Rothschild presented a sketch by Jean-Michel Cels, *Tree Study*, and others have followed her example. Many of the artists working in Italy later returned to their own countries to continue the practice of painting in the open air. Some, for example Théodore Rousseau, never travelled to Italy at all, but we are now able to compare Rousseau's early sketches in the Auvergne region of his native France with those of an artist such as Corot who honed his talents in Italy before turning his attention to his home country.

Today the National Gallery's collection can trace the story of nineteenth-century landscape practice from the plein-air traditions in late eighteenth-century Italy through to artists such as Corot and Boudin, whose subject matter, handling and palette were to be so important for the Impressionists. Acquisition policies shift and change, and in 2009 the Gallery's attention is more often focused on twentieth-century artists. But as a result of the generosity of those collectors mentioned here and other benefactors, the Gallery is able to provide the finest, most complete survey of nineteenth-century landscape painting to be found in this country.

Sarah Herring

1 Pierre-Henri de VALENCIENNES (1750–1891) *Cow-shed and Houses*
on the Palatine Hill, about 1782–4

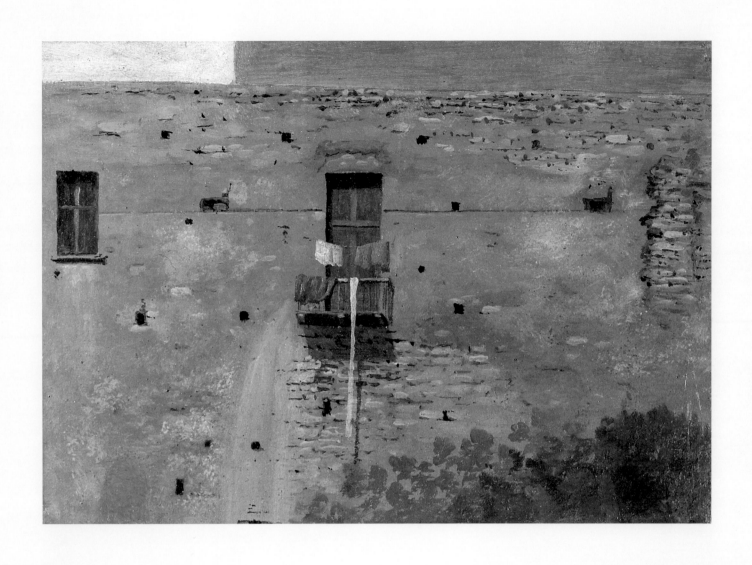

2 Thomas JONES (1742–1803) *A Wall in Naples*, about 1782

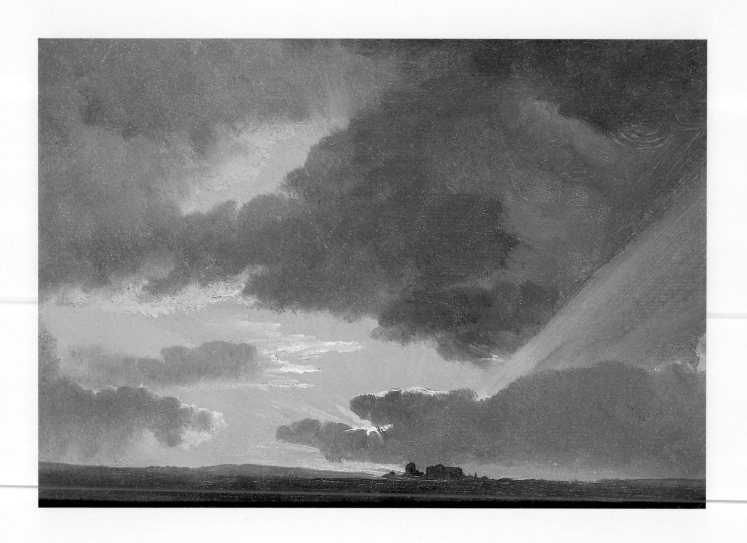

3 Simon DENIS (1755–1812) *Sunset in the Roman Campagna*, between 1786 and about 1803

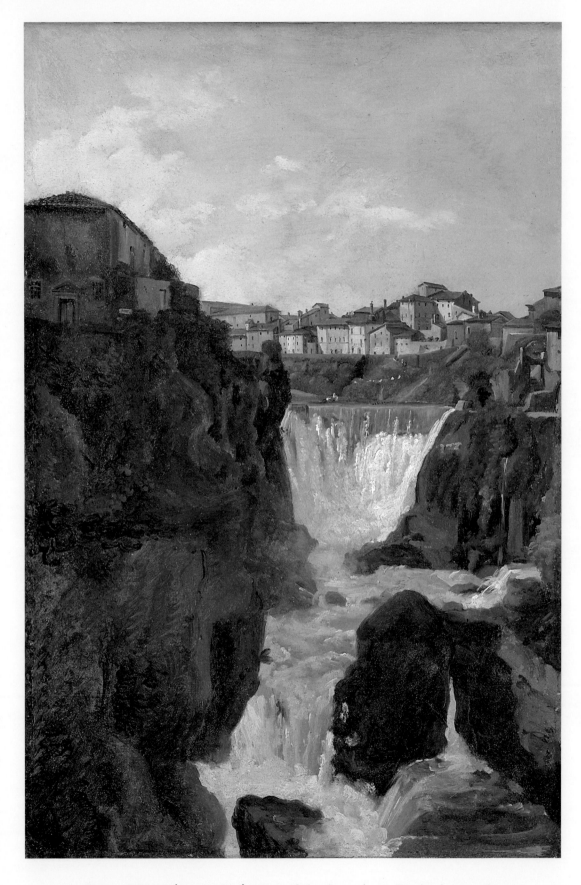

4 Simon DENIS (1755–1812) *View of the Cascades at Tivoli*, about 1789–93

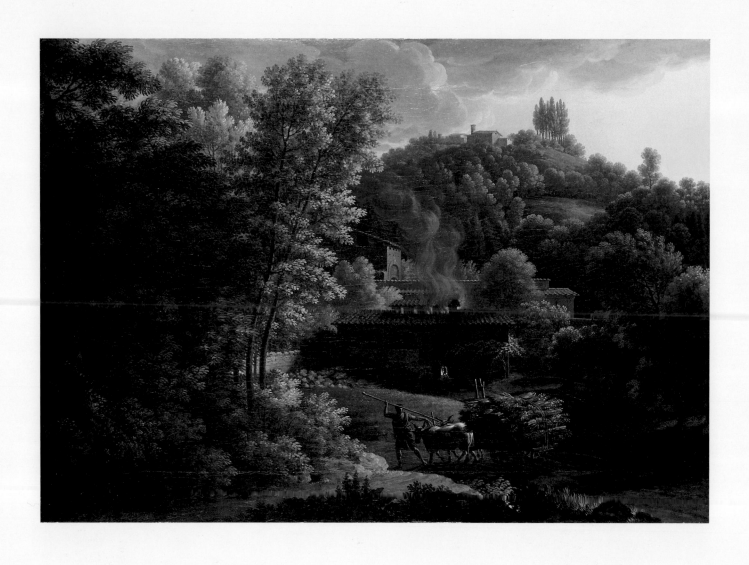

5 François–Xavier FABRE (1766–1837) *Italian Landscape,* 1811

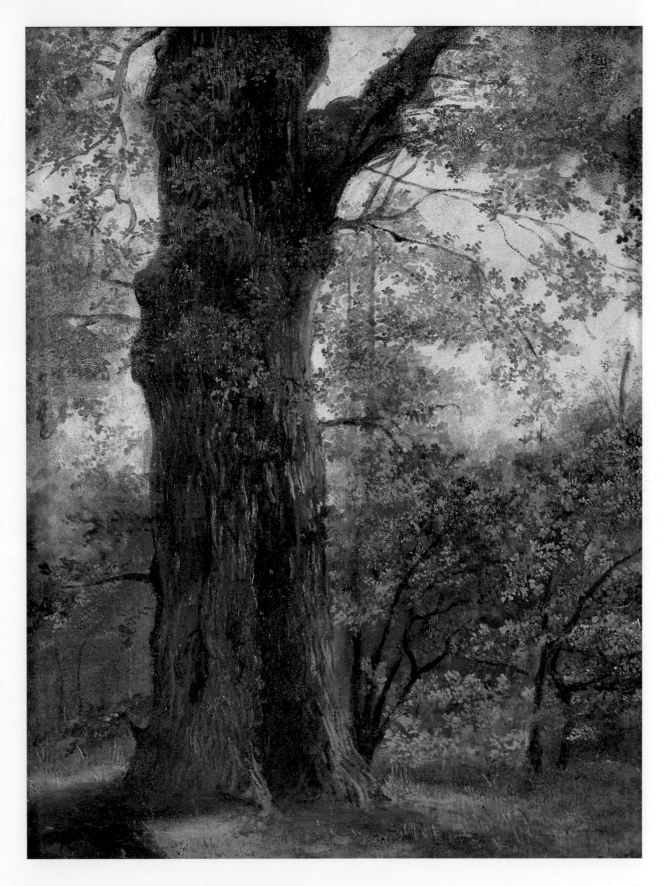

6 Achille-Etna MICHALLON (1796–1822) *A Tree*, about 1816–17

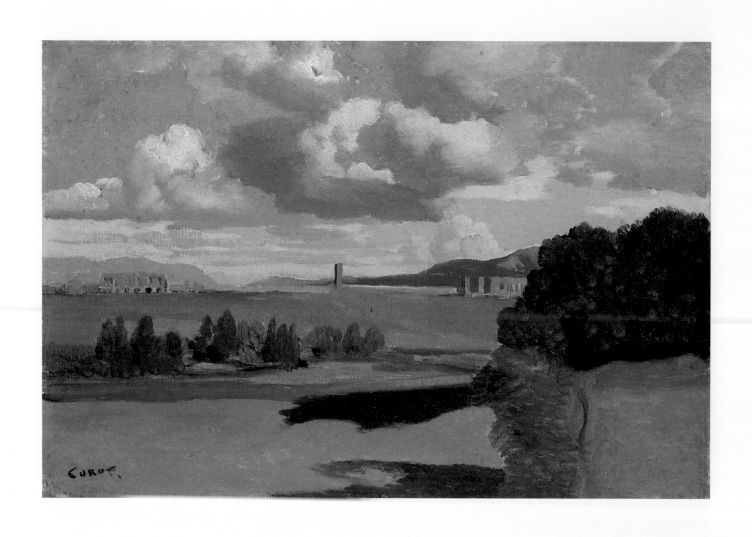

7 Jean-Baptiste-Camille COROT (1796–1875) *The Roman Campagna, with the Claudian Aqueduct,*
probably 1826

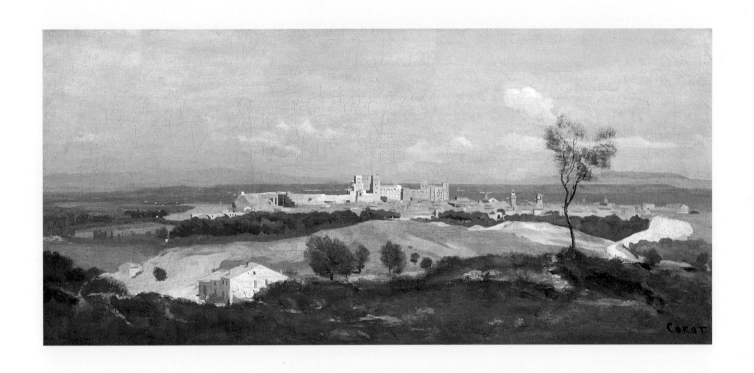

8 Jean-Baptiste-Camille COROT (1796–1875) *Avignon from the West*, probably 1836

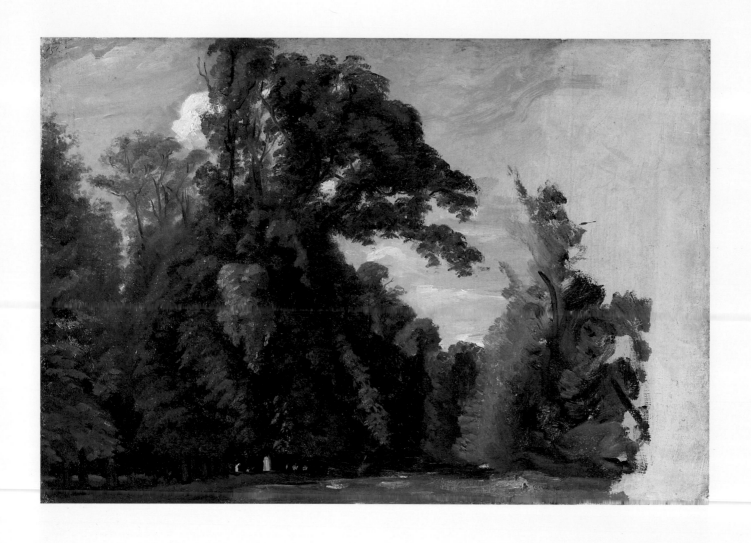

9 Paul HUET (1803–1869) *Trees in the Park at Saint-Cloud*, about 1820

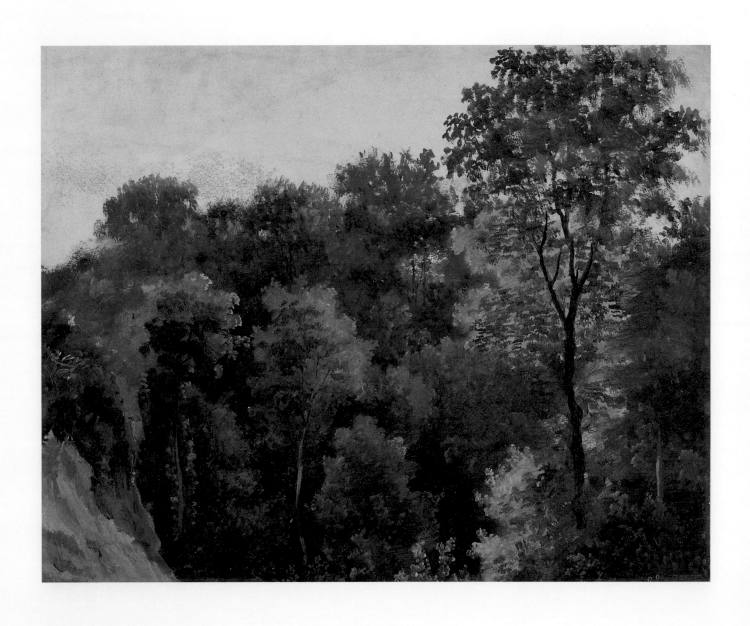

10 Jean-Michel CELS (1819–1894) *Tree Study*, about 1840

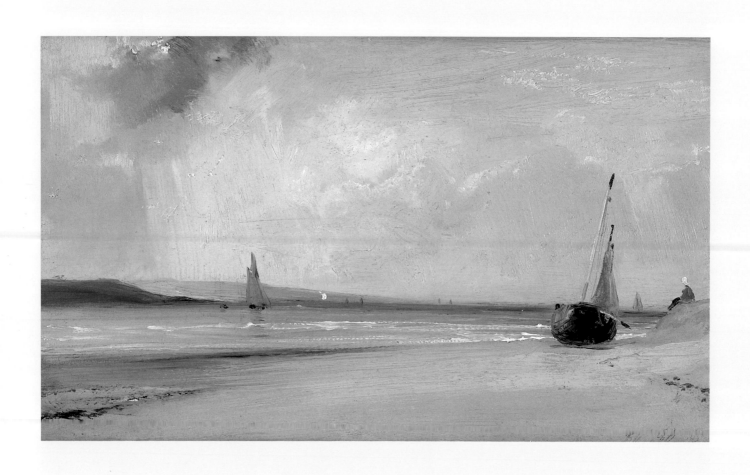

11 Richard Parkes BONINGTON (1802–1828) *La Ferté*, about 1825

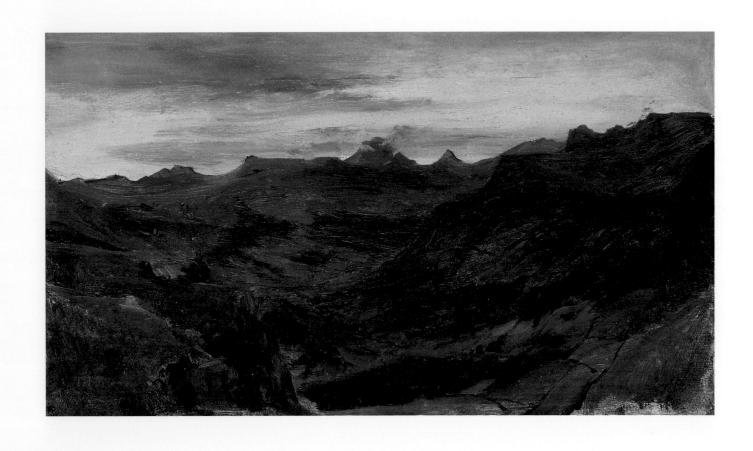

12 Théodore ROUSSEAU (1812–1867) *The Valley of Saint-Vincent*, 1830

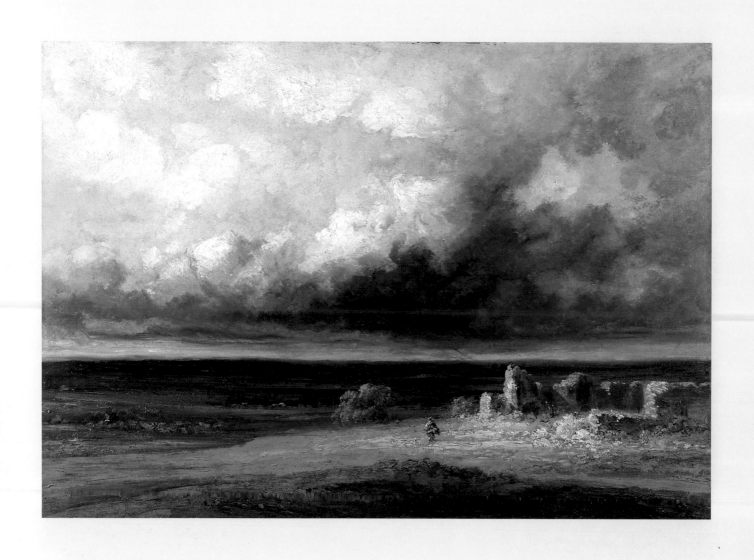

13 Georges MICHEL (1763–1843) *Stormy Landscape with Ruins on a Plain*, after 1830

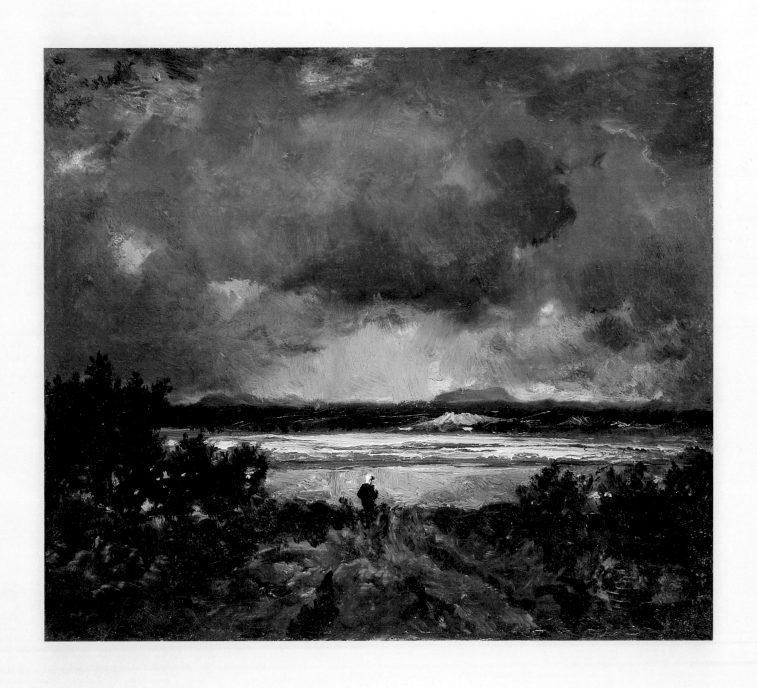

14 Théodore ROUSSEAU (1812–1867) *Sunset in the Auvergne*, possibly 1844

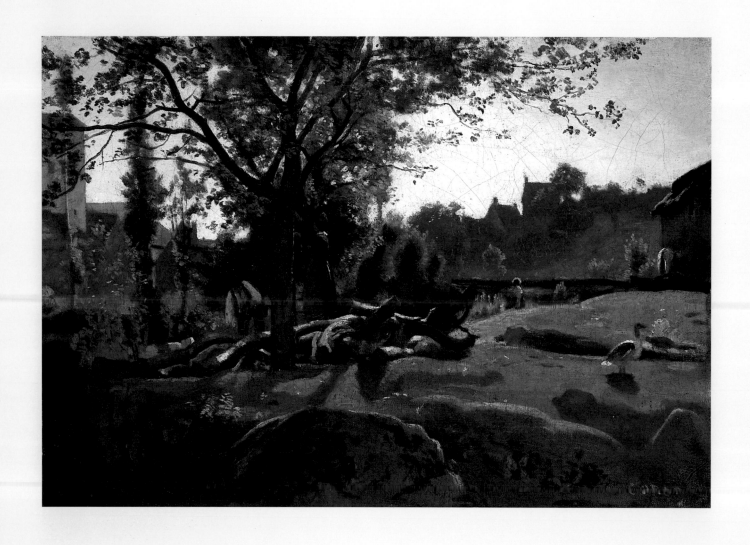

15　Jean-Baptiste-Camille COROT (1796–1875) *Peasants under the Trees at Dawn,* about 1840–5

16　French (?) *Excavation of the Roman Theatre, Orange, France,* first half of the 1850s

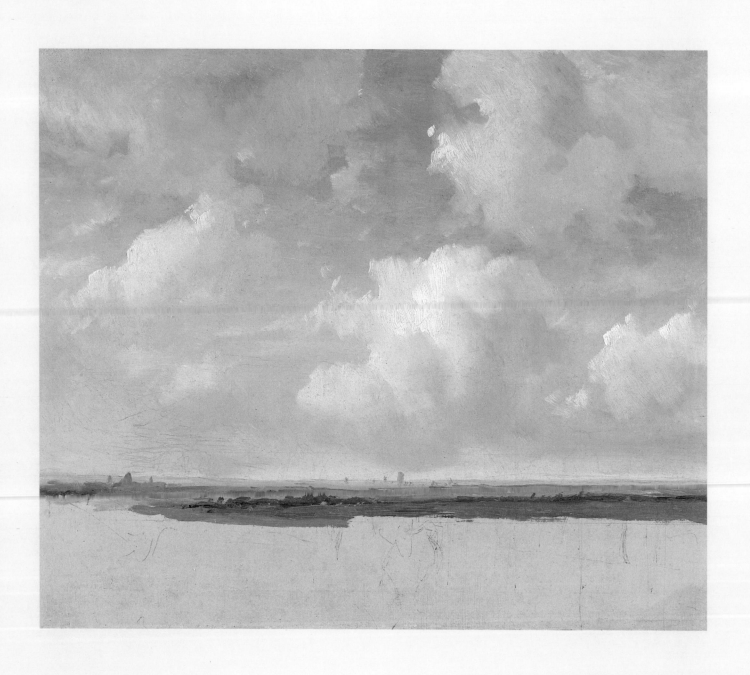

17　Andreas SCHELFHOUT (1787–1870) *Landscape with Cumulus Clouds,*
with View of Haarlem on the Horizon, about 1839

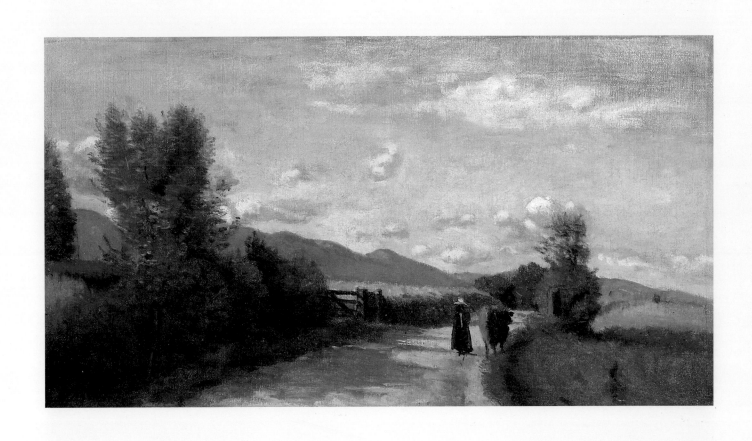

18 Jean-Baptiste-Camille COROT (1796–1875) *Dardagny*, probably 1853

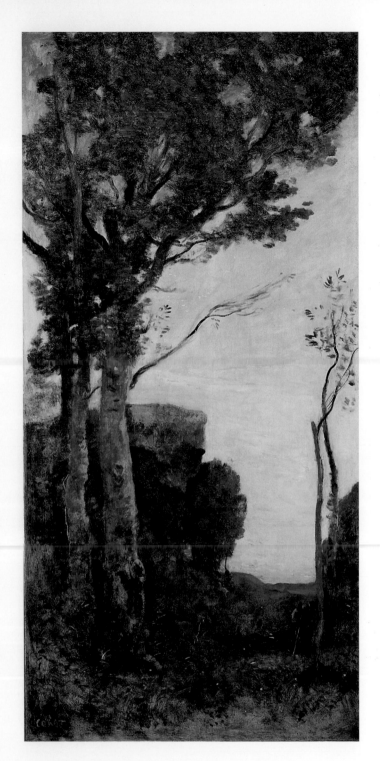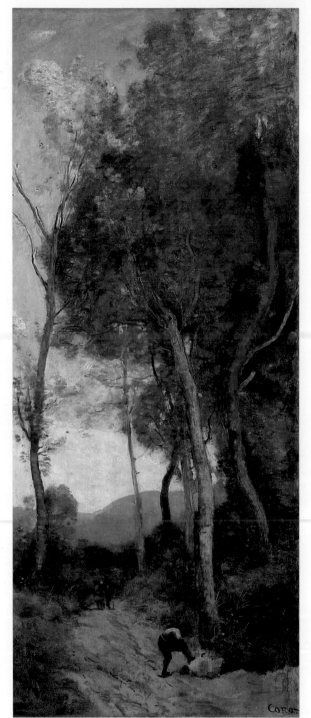

19 Jean-Baptiste-Camille COROT (1796–1875) *The Four Times of Day: Morning*, about 1858

20 Jean-Baptiste-Camille COROT (1796–1875) *The Four Times of Day: Noon*, about 1858

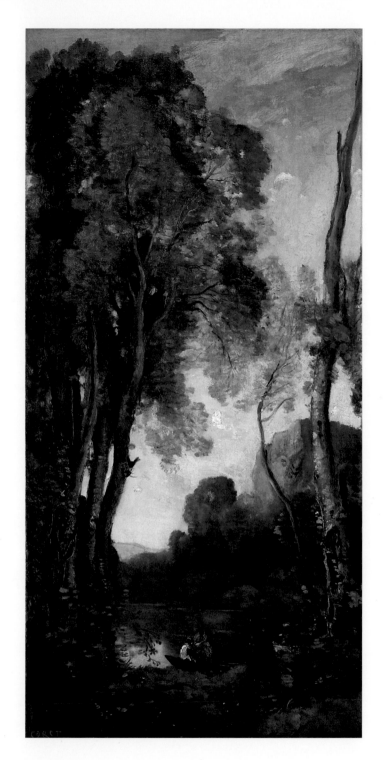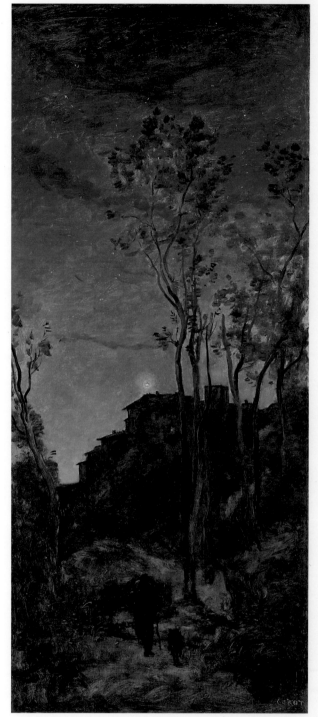

21 Jean-Baptiste-Camille COROT (1796–1875) *The Four Times of Day: Evening,* about 1858

22 Jean-Baptiste-Camille COROT (1796–1875) *The Four Times of Day: Night,* about 1858

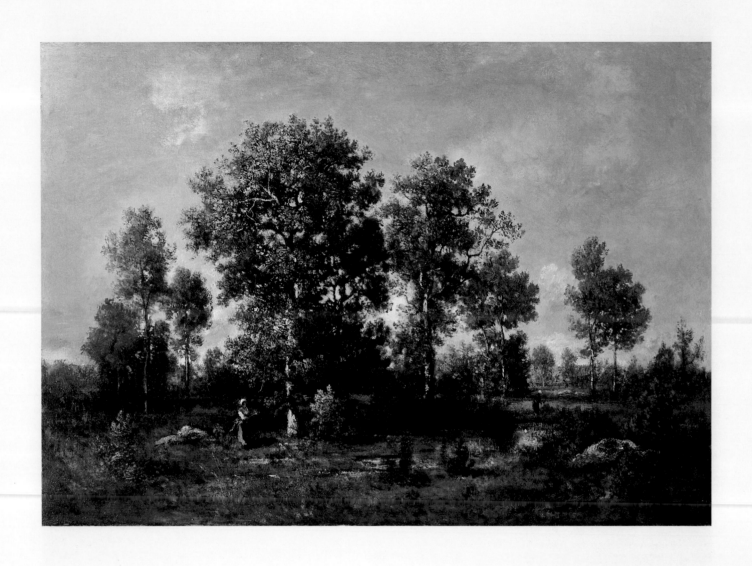

23 Narcisse-Virgilio DIAZ DE LA PEÑA (1807–1876) *Sunny Days in the Forest*, probably 1850–60

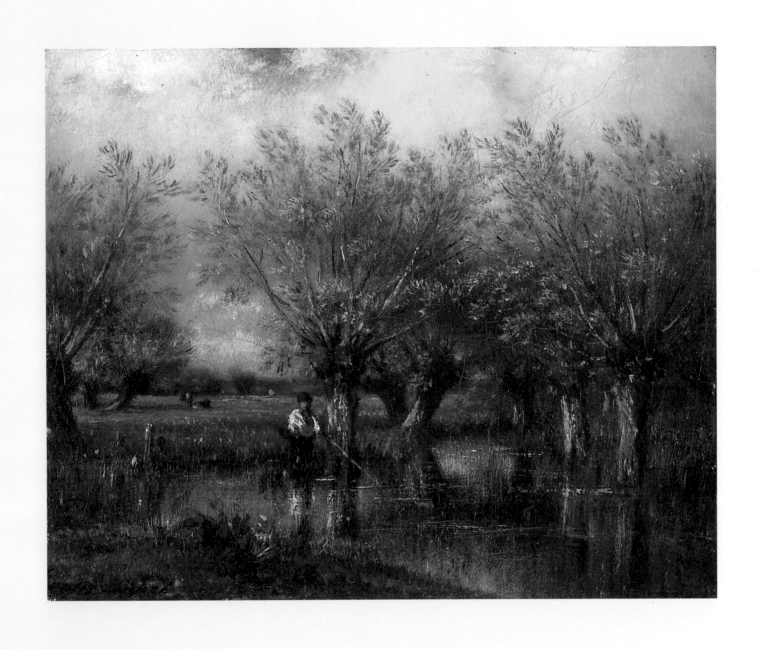

24 Jules-Louis DUPRÉ (1811–1899) *Willows, with a Man fishing,* probably before 1867

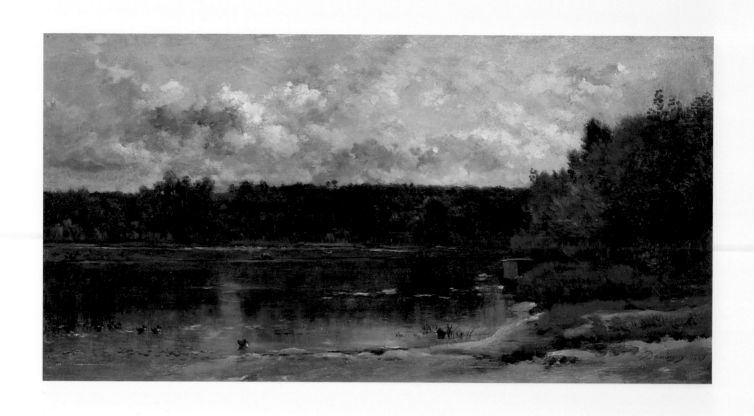

25 Charles-François DAUBIGNY (1817–1878) *River Scene with Ducks*, 1859

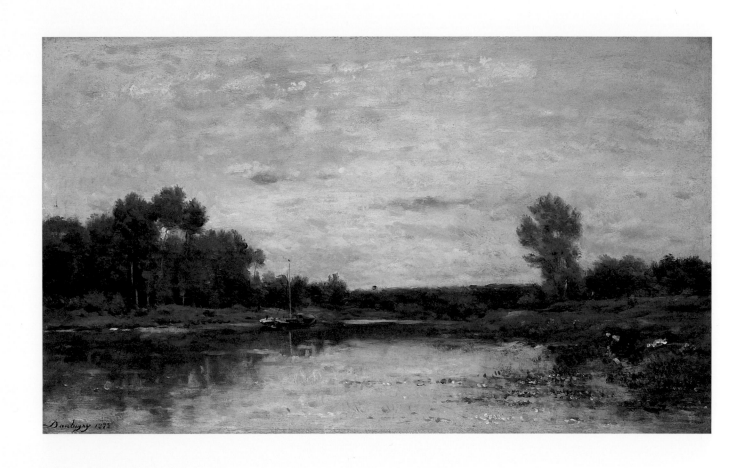

26 Charles-François DAUBIGNY (1817–1878) *View on the Oise*, 1873

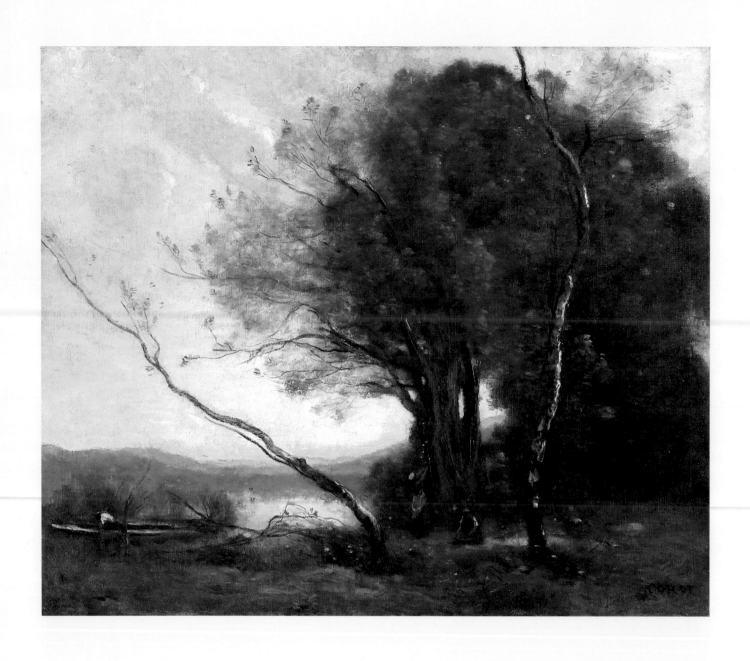

27 Jean-Baptiste-Camille COROT (1796–1875) *The Leaning Tree Trunk*, about 1860–5

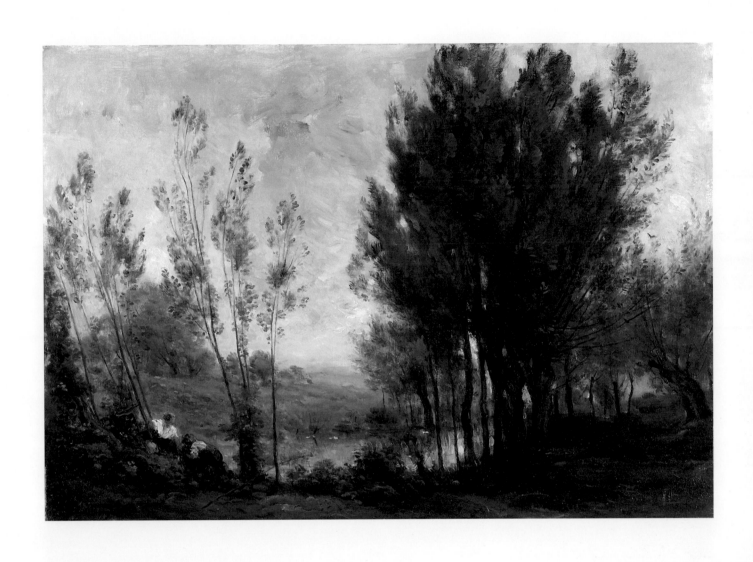

28 Charles-François DAUBIGNY (1817–1878) *Willows,* 1872 or 1874

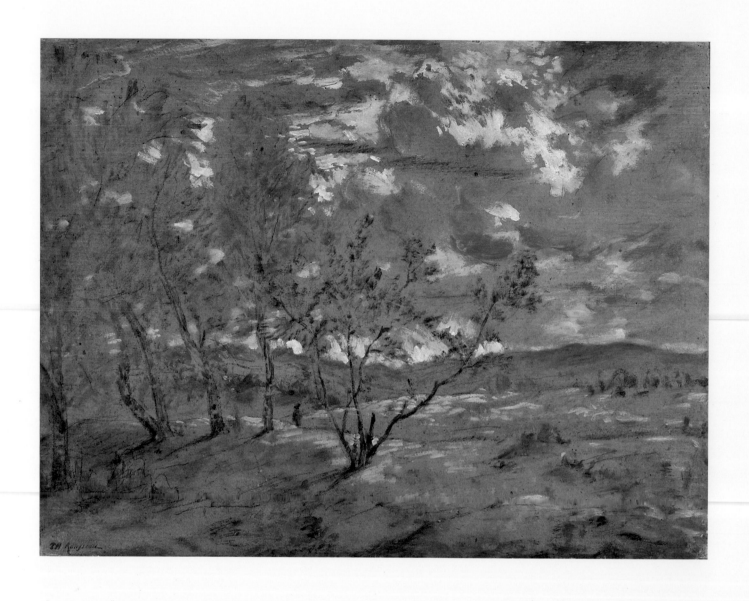

29 Théodore ROUSSEAU (1812–1867) *Landscape*, about 1865

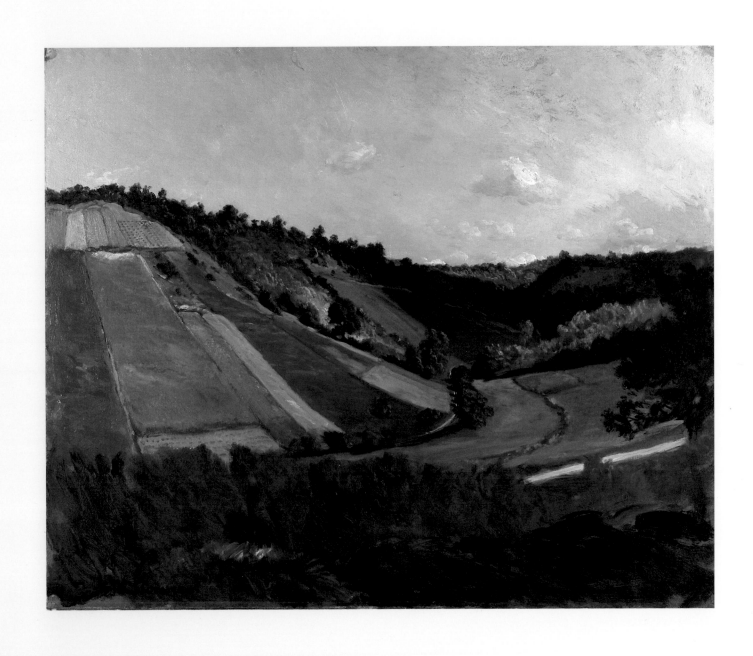

30 Philippe ROUSSEAU (1816–1887) *A Valley*, about 1860

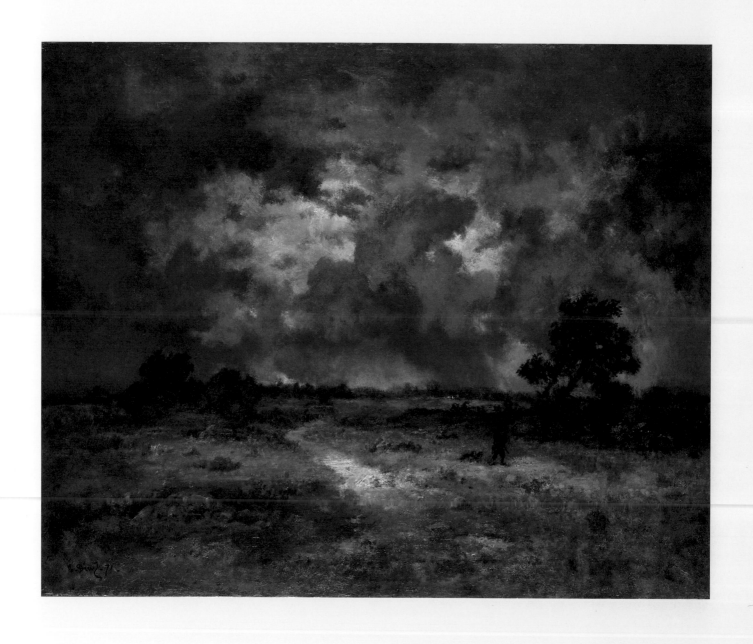

31 Narcisse-Virgilio DIAZ DE LA PEÑA (1807–1876) *The Storm*, 1871

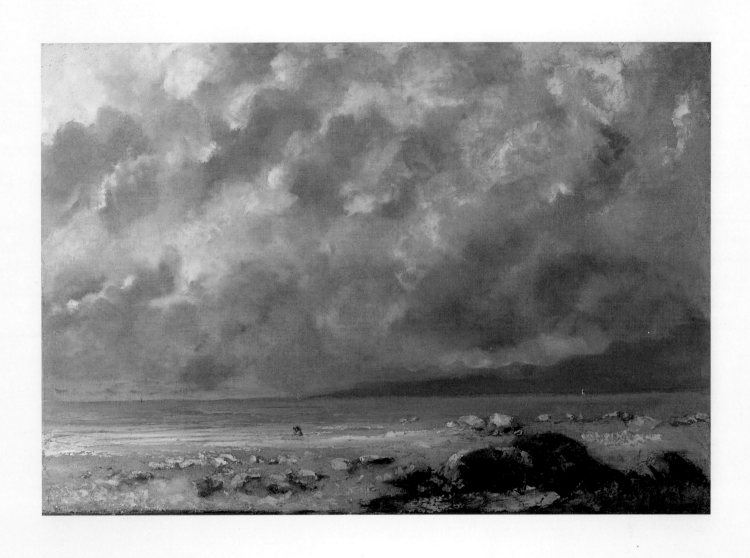

32 Gustave COURBET (1819–1877) *Beach Scene*, 1874

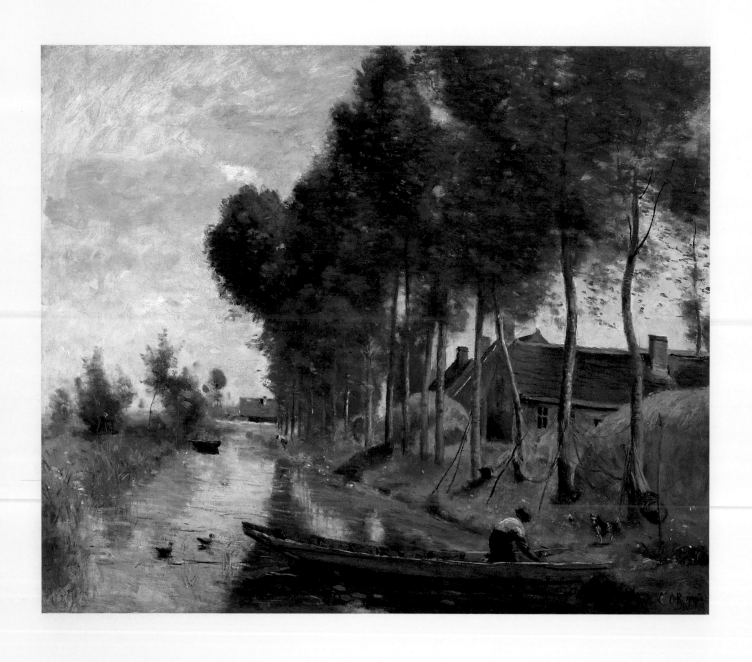

33 Jean-Baptiste-Camille COROT (1796–1875) *Landscape at Arleux-du-Nord*, 1871–4

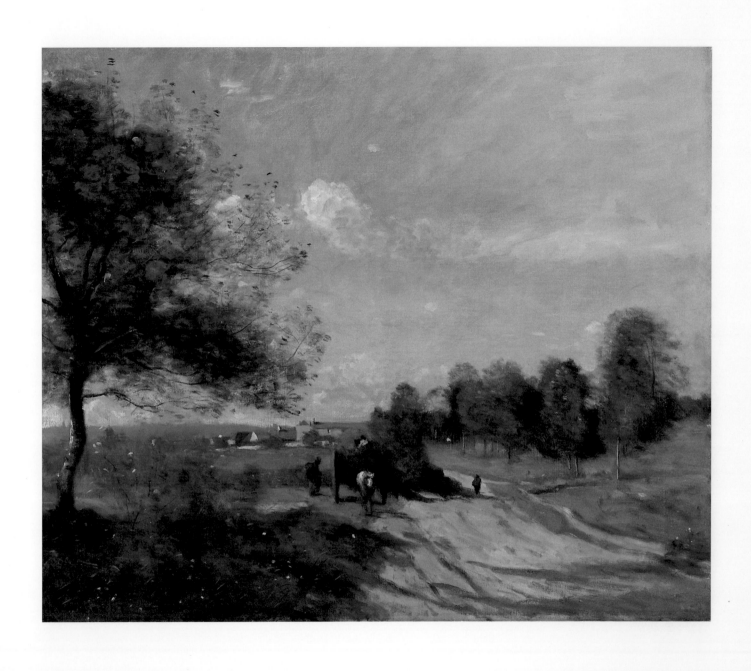

34 Jean-Baptiste-Camille COROT (1796–1875) *The Wagon ('Souvenir of Saintry')*, 1874

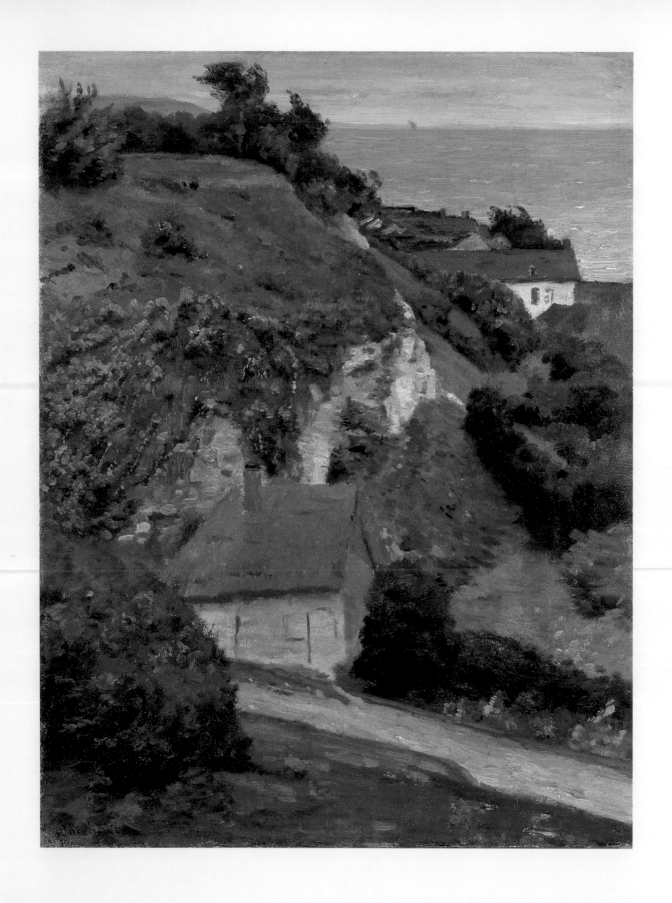

35 Antoine CHINTREUIL (1814–1873) *Houses on the Cliffs near Fécamp*, probably 1861

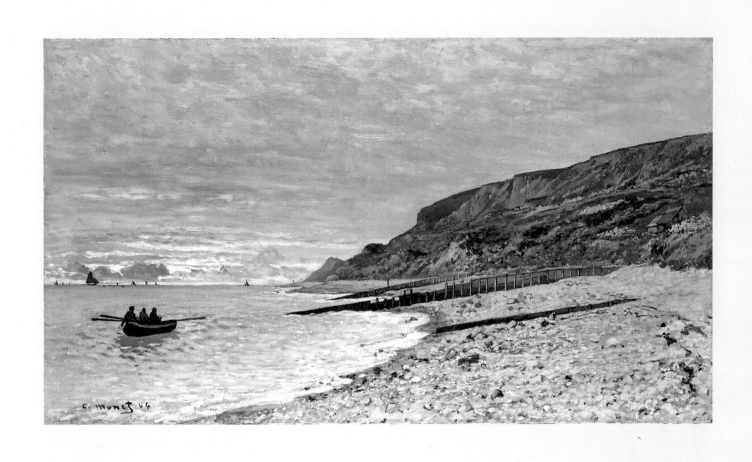

36　Claude-Oscar MONET (1840–1926) *La Pointe de la Hève, Sainte-Adresse*, 1864

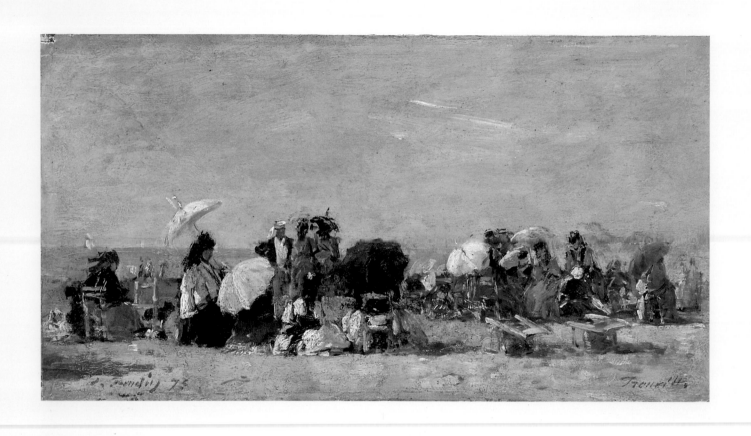

37 Eugène BOUDIN (1824–1898) *Beach Scene, Trouville*, 1873

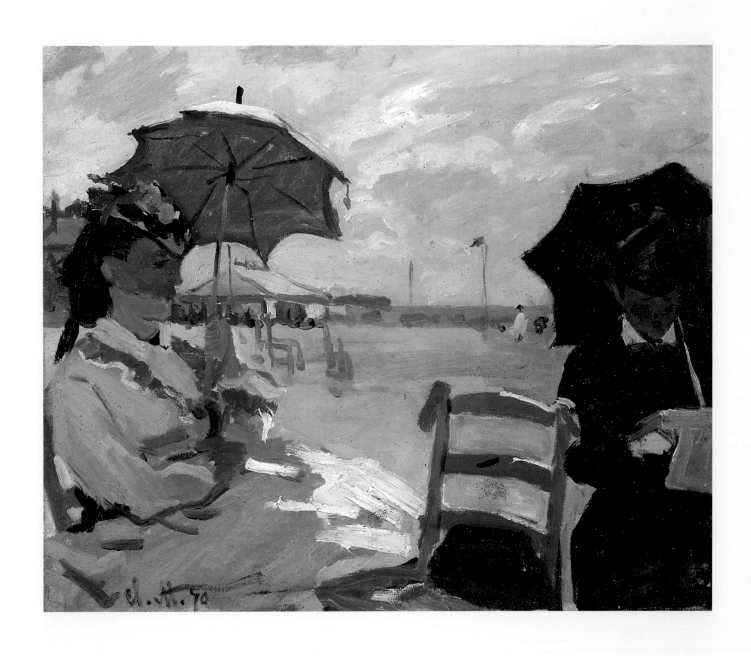

38 Claude-Oscar MONET (1840–1926) *The Beach at Trouville,* 1870

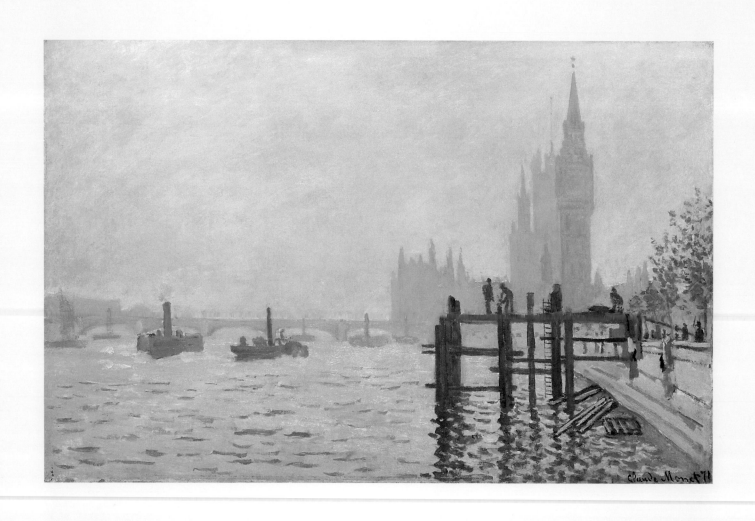

39 Claude-Oscar MONET (1840–1926) *The Thames below Westminster*, about 1871

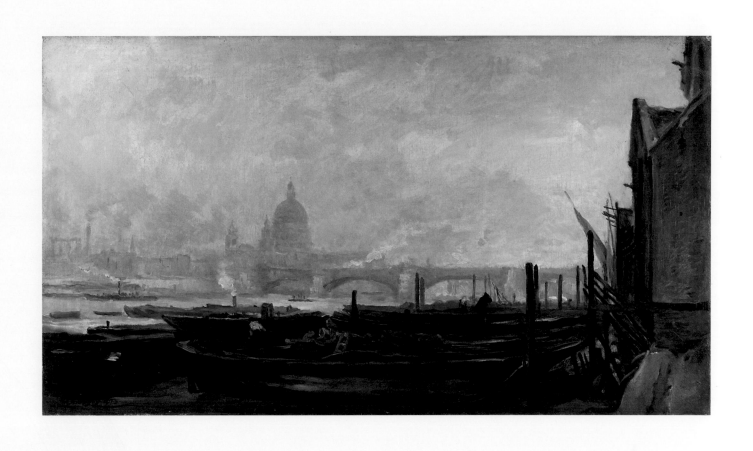

40 Charles-François DAUBIGNY (1817–1878) *St Paul's from the Surrey Side*, 1871–3

1 Pierre-Henri de VALENCIENNES (1750–1819)
Cow-Shed and Houses on the Palatine Hill, about 1782–4
Oil on paper laid on canvas, 23.1 x 37.8 cm
The Gere Collection, on long-term loan to the National Gallery

Rome was an important training ground for Valenciennes as a landscape painter. He travelled there twice (from 1777–81 and from 1782–4). Shortly before his second visit Valenciennes met Claude-Joseph Vernet in Paris in 1781–2, and Vernet's advice to paint outdoors directly from nature may have been important for him. In this sketch, under an oppressively monochrome sky, Valenciennes contrasts the ruined Roman structures, their arcades surrounded by vegetation, with the squared modern constructions, probably cow-sheds. Striking too is the opposition of lights and shadows, to which Valenciennes dedicated an entire chapter of his important treatise on painting technique, *Élémens de perspective pratique* (1800).

The painting is more freely worked than a related pen and wash drawing of the same scene (now in the Musée du Louvre, Paris), and includes some errors in perspective such as the white wall on the left, which is much more precisely positioned in the drawing.

AM

2 Thomas JONES (1742–1803)
A Wall in Naples, about 1782
Oil on paper laid on board, 11.4 x 16 cm
Bought, 1993

This tiny but significant picture is the only one in the collection by the innovative Welsh painter Thomas Jones. Jones was among those artists who towards the end of the eighteenth century were irresistibly drawn to Italy, its landscape and light.

Naples was fundamental for his stylistic development. Here, in 1782–3, he began to make oil sketches directly after nature, mostly from the *lastricia*, the typical flat roof of the various Neapolitan houses in which he rented rooms. About a dozen such studies of buildings survive, and this is arguably the most remarkable of them.

Despite the naturalistic observations, such as the decrepit wall, the water corrosion and the vertical mid-summer shadows, the painted space is rationally planned. With a photographic eye, Jones 'cuts' the picture surface in proportioned rectangles. Apart from the predominant grey, three colours recur: white, blue and green. In the centre of the composition, they reappear synthesised in the form of the laundry. The long, vertical white 'dribble' is the keystone of the composition.

AM

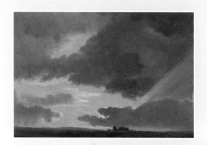

3 Simon DENIS (1755–1812)
Sunset in the Roman Campagna, between 1786 and about 1803
Oil on paper, 18.2 x 26.2 cm. Signed on the back: a Rome. S. Ds
Bought, 1996

Simon Denis lived in Italy, primarily Rome, from 1786 until his death. The Roman *Campagna*, with its hilly configuration and unique light, was a perfect setting for painters who were interested in interpreting the forms of nature, and in catching the ephemeral phases of daylight. Sunset was an ideal moment often chosen by artists, because of its brevity and dramatic light effects, with rays that seem to come straight from the earth.

Denis's sketch demonstrates the artist's skill in manipulating the oil medium to portray radiant light. The rays of the setting sun, streaming from the clouds, are rendered in strong, linear brushstrokes, while a thicker and more heavily applied paint is used for the lowering mass of dark clouds.

AM

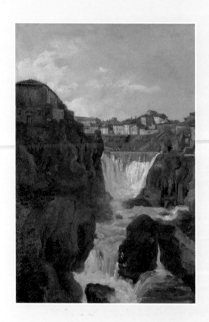

4 Simon DENIS (1755–1812)
View of the Cascades at Tivoli, about 1789–93
Oil on paper laid on linen, 38.6 x 25.8 cm
The Gere Collection, on long-term loan to the National Gallery

The Belgian painter Simon Denis moved to Paris in the early 1780s, where he met artists such as Pierre-Henri de Valenciennes and Jean-Baptiste Lebrun. The latter encouraged him to travel to Rome, where he arrived in 1786. For any landscape painter working in Rome at that time, the nearby town of Tivoli in the *Campagna*, with its 'romantic' cascades and ruins, was an essential point of reference and interest. Six paintings in the Gere Collection show aspects of the site.

In this picture, Denis shows the cascades of the river Aniene, a tributary of the Tiber. Tivoli is compressed into a strip, while the larger portion of the composition is occupied by nature. The water is dominant; it flows beyond the lower edge of the painted space, and even the clouds seem to evoke its foaming descent. Two tiny female figures are washing laundry above the cascade; a naturalistic detail certainly sketched from real life.

AM

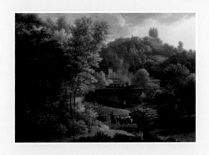

5 François-Xavier FABRE (1766–1837)
Italian Landscape, 1811
Oil on canvas, 47.8 × 68.4 cm
Presented by Mrs Linda Murray in memory of her husband Peter Murray,
through The Art Fund, 1996

On winning the Prix de Rome in 1787 Fabre studied in that city before moving
to Florence, where he lived from 1793 to 1826. During this period he turned
increasingly to landscape painting. This idealised composition is both rooted in the
classical seventeenth-century landscape traditions of Nicolas Poussin and Gaspard
Dughet, and shows Fabre's awareness of contemporary developments in landscape
painting, when plein-air sketching was increasing in importance.

The central group of drover, oxen and cart probably derives directly from Gaspard
Dughet. However, the wooded landscape and buildings – the central one is
probably a charcoal furnace – are reminiscent of the Bagni di Lucca, an area
north-west of Florence where Fabre went on sketching expeditions. Added to this
sense of place are the naturalistic but dramatic light effects. Stormy clouds on the
far left gradually give way to a clear evening light, which touches the landscape
with rose.

SH

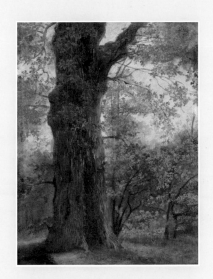

6 Achille-Etna MICHALLON (1796–1822)
A Tree, about 1816–17
Oil on paper, 30.5 × 24.0 cm
The Gere Collection, on long-term loan to the National Gallery

Achille-Etna Michallon, despite his brief career, was of great significance for
Corot's artistic education. Corot was in fact in his studio for few months, early in
1822, just before Michallon's premature death in September of that year.

Pierre-Henri de Valenciennes, Michallon's teacher, in his treatise *Élémens de
perspective pratique* (1800) advised artists to make studies of trees, to choose
those which present an intense *clair-obscur,* and to focus on their bark. This oil
sketch shows an old oak, its trunk hollow at the base; in contrast, the tree has
young branches and fresh leaves. A strong back-lit effect, which accentuates the
monumentality of the tree, is created by the milky-coloured sky. On the reverse
of the sheet is a study of a farmhouse, and a nearby wood. Michallon may have
made this sketch in France, just before he went to Rome in early 1817, although
the autumnal foliage suggests a date late in the year, perhaps at the end of 1816.

AM

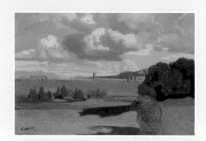

7 Jean-Baptiste-Camille COROT (1796–1875)
The Roman Campagna, with the Claudian Aqueduct, **probably 1826**
Oil on paper, laid down on canvas, 22.3–22.8 x 34.0 cm
Bought at the Degas sales (with a special grant), 1918

Following in the footsteps of artists from all over Europe, Corot made his first and longest trip to Italy from 1825 to 1828. Arriving in Rome in November 1825, he made a series of open-air studies of both the city and the surrounding countryside, probably painting this view in the spring of 1826. In the background stand the remains of the Claudian Aqueduct, completed in AD 52, which were visible to the south of the city. At the centre stands the Tor Fiscale, a medieval defence tower, and to the right and left lie the Alban and Prenestini Hills. Over an unseen fragmentary drawing Corot swiftly and confidently painted the landscape in one single layer of paint. Working with a small range of colours – greens, beiges, violets, blues and whites – he perfectly captured the broad sunlit landscape under a blue sky hung with bright majestic clouds.

SH

8 Jean-Baptiste-Camille COROT (1796–1875)
Avignon from the West, **probably 1836**
Oil on canvas, 34.0 x 73.2 cm
Sir Hugh Lane Bequest, 1917

During his visit to Avignon in 1836 Corot painted a number of plein-air studies of the town and its neighbour Villeneuve-lès-Avignon. In this view both branches of the Rhône can be seen on the left, with the remains of the Pont Saint-Bénézet. To the right stands the Rocher des Domes, and the stepped wall emerging from the former Bishop's Palace. The prominent left-hand tower is that of the Cathedral (Notre-Dame des Domes); that on the right and the remaining buildings are the Papal Palace, which has been restored since Corot's time. In this sun-drenched view Corot has applied the paint in a similar manner to that of his Italian views, laying blocks of colour side by side and constructing the architecture out of light and dark. The foreground was originally thinly and loosely painted, but quite soon after completing the picture Corot reworked it with a substantial layer of khaki green paint.

SH

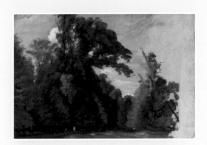

9 Paul HUET (1803–1869)
Trees in the Park at Saint-Cloud, about 1820
Oil on canvas, 37.5 × 55.2 cm
Presented by the Lishawa Family in memory of Kate (Lishawa), 2005

While Huet was attending the studio of Baron Gros, from 1819–22, he was also exploring areas around Paris, particularly the former royal park at Saint-Cloud in the western suburbs, where he painted a number of views of the magnificent trees. Laid out by André le Nôtre in the seventeenth century, the park still retains its ornamental lakes and fountains and through the trees at the left the jet of a fountain can be glimpsed.

Huet described the park as 'this enchanted site...whose every bush I knew, where I cried for every tree cut down, as I would for a lost friend.' Here he has distilled the grandeur and stillness of the stately trees, masterfully capturing the play of light on the foliage on the far left. The brushwork becomes increasingly vigorous towards the unfinished right-hand side where he has concluded the study with a few calligraphic swirls and loops of paint.

 SH

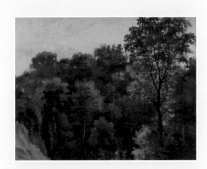

10 Jean-Michel CELS (1819–1894)
Tree Study, about 1840
Oil on paper mounted on canvas, 23.2 × 29.8 cm
Presented by Kate de Rothschild, 1999

This oil sketch of trees growing in a deep ravine would have been painted directly from nature. By the turn of the nineteenth century all landscape artists made direct oil studies in the open air, a practice codified by Pierre-Henri de Valenciennes in his *Elémens de perspective pratique* of 1800. Among the subjects he advocated were beautiful trees, both detailed individual specimens and woodland.

Cels's choice of subject was probably influenced by Valenciennes. He has approached the trees in two different ways. Those set deep in the gully have been highlighted in lighter shades of green to bring them into relief against the dark mass of foliage. For others, particularly those set against the creamy sky, and the principal tree to the right, silhouetted against the very light fresh green of the tree behind it, one shade only is used, and the swift brushstrokes themselves define the shapes of the leaves.

 SH

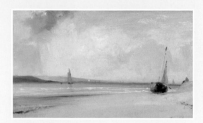

11 Richard Parkes BONINGTON (1802–1828)
La Ferté, about 1825
Oil on fibreboard, 16.3 – 16.7 x 27.9 cm
Accepted by HM Government in lieu of Inheritance Tax and allocated to the
National Gallery pending a decision on permanent allocation, 2007

Although born of English parents, Bonington spent most of his short life in France. An inveterate traveller, he made a number of tours of Normandy and Picardy, frequently sketching at St-Valéry-sur-Somme and nearby La Ferté on the Picardy coast with his painting companions, Paul Huet and Thomas Shotter Boys.

This study, probably a view of La Ferté, was made on the spot. The whole is quickly and fluidly painted with the stretches of sand, sea and sky painted with one horizontal sweep of the brush. Small details such as the boat on the left and the small boat in the distance on the right are painted wet-in-wet, the vertical brushstroke cutting through the sweeping strokes of the sky. The artist probably added both the boat on the right and the woman, back in the studio. The fluid handling and limpid light are typical of his sea pieces, which reached a height of accomplishment around 1825–6.

SH

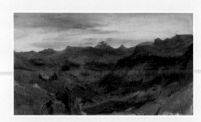

12 Théodore ROUSSEAU (1812–1867)
The Valley of Saint-Vincent, 1830
Oil on paper laid down on canvas, 18.2 x 32.4 cm
Bought, 1918

In 1830 Rousseau made a trip to the Auvergne, where he spent several months in the company of the landscape painter Prosper Marilhat. Auvergne, then an area of wild, unspoilt nature, was seminal in Rousseau's development, and it was with views of the region that he exhibited for the first time at the Paris Salon in 1831. This is a view of the Vallée du Falgoux, in which the village of Saint-Vincent lies. It is one of the valleys radiating out from the foot of Puy Mary, one of the principal summits of the Cantal region, and the highest peak visible at the centre.

The long fluid brushstrokes following the contours of the valley and the mountains are typical of the works Rousseau produced during this trip. After the artist's death the sketch was extended by a narrow strip at the top, whose differing coloration marks it out from the rest of the composition.

SH

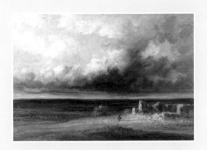

13 Georges MICHEL (1763–1843)
Stormy Landscape with Ruins on a Plain, after 1830
Oil on paper laid down on canvas, 55.7 x 81.0 cm
Presented by T.W. Bacon through The Art Fund, 1910

Michel was largely self taught, but much influenced by seventeenth-century Dutch and Flemish painters whose works he copied and restored. He worked entirely in the surroundings of Paris, favouring particularly Montmartre with its windmills and the plains of St-Denis. This painting is typical of his mature work, which was characterised by panoramic landscapes under stormy skies rendered with broad brushstrokes. In the right foreground lie ruins, while a lone figure, characteristic of Michel's work, is pitted against the forces of nature.

Michel has varied greatly the handling of the paint, from thick, horizontal strokes for the plain to a thinner, washier layer for the ruins. Highlights and the stones are picked out with a loaded brush in cream and beige. Areas of the sky are quite thin, particularly the grey clouds, whereas the white clouds to the left are painted in thick impasto.

SH

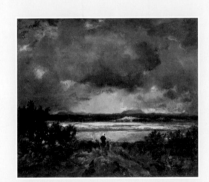

14 Théodore ROUSSEAU (1812–1867)
Sunset in the Auvergne, possibly 1844
Oil on mahogany (?) panel, 20.5 x 23.9 cm
Salting Bequest, 1910

Under a stormy sunset sky lies a distant range of mountains. In the middle ground a plain is painted in creams, yellows and greens, with an expanse of water in front, reflecting a pink streak of sky. The influence of Michel is evident in the solitary figure standing at the water's edge, dwarfed by the immensity of nature.

Although this painting is associated with the Auvergne, where Rousseau travelled and worked in 1830, doubts have been expressed that this view dates from so early in his career. The agitated and choppy brushwork, quite unlike the smooth and linear brushstrokes of the Auvergne paintings, fits more clearly with the artist's work of the 1840s. It is possible, indeed that this is a view of the Pyrenees. In 1844 Rousseau, accompanied by Jules Dupré, visited the Pyrenees and the area south of Bordeaux.

SH

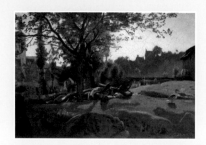

15 Jean-Baptiste-Camille COROT (1796–1875)
Peasants under the Trees at Dawn, about 1840–5
Oil on canvas, 27.3 x 38.8 cm
Bought, 1977

Under a spreading tree a man saws and a woman gathers twigs. The scene is in Lormes, the principal town in the area of the Morvan, in western Burgundy, then known for its rugged terrain and somewhat remote character. The inhabitants lived mainly by the timber trade and dairy farming.

Corot's father's family originated from the region and in the early 1840s the artist made three long visits there. His views of the area are characterised by high horizons and striking light effects, both features of this painting. Here the buildings and trees appear to dissolve in the pale, clear light shed from the horizon. Corot has painted the sky last, bringing it around the roofs and trees. As a final touch he has added further spreading branches of the foremost tree, over the sky on both sides, a practice he followed throughout his life.

SH

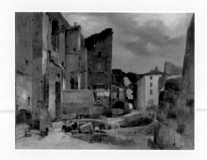

16 French (?)
Excavation of the Roman Theatre, Orange, France, first half of the 1850s
Oil on paper laid on canvas, 24.7 x 32.7 cm
The Gere Collection, on long-term loan to the National Gallery

This sketch represents the Roman theatre at Orange, in south-east France, during the archaeological excavations initiated by Prosper Mérimée, the writer, historian and archaeologist; he was also director of the 'Monuments Historiques', the organisation which surveyed and maintained the historic sites of France from the 1830s onwards. The works in Orange were completed in 1856, and a photograph taken in about 1861 by Edouard Baldus shows a much more orderly site. This sketch, however, captures the works at a relatively early stage, when the theatre's risers had not yet been excavated.

At this date oil sketching on paper was a common practice all over Europe. The almost photographic quality of the light suggests that the unknown artist was working from nature. There are also fascinating naturalistic observations, such as the man who drags a wheelbarrow on the left and the two master builders discussing plans on a fragment of antique stone.

AM

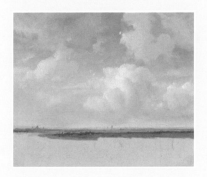

17 Andreas SCHELFHOUT (1787–1870)
Landscape with Cumulus Clouds, with View of Haarlem on the Horizon,
about 1839
Oil on paper, laid on canvas, 24.5 × 29.3 cm
The Gere Collection, on long-term loan to the National Gallery

This is a rare surviving oil sketch by the celebrated Dutch nineteenth-century landscape painter, and a preparatory study for the clouds that appear in a more finished *View of Haarlem* – signed and dated 1839 – in the Victoria and Albert Museum, London.

For his vantage point, Schelfhout chose a sand dune, from which he could capture the ever-changing effects of the light on the clouds. The result is a fresh and immediate sense of their volume and density, and the warmth of the lighting effects, all rendered by daubs of paint.

The sketch was discovered not in Schelfhout's studio, but in that of a contemporary, the Belgian artist Gilles Closson (1798–1842). Painters often exchanged such sketches and they remained in their studios for future reference. Here, Schelfhout seems to have been reusing a piece of paper, as is indicated by the presence of another sketch in pencil, parts of which are visible at the bottom of the picture.

AM

18 Jean-Baptiste-Camille COROT (1796–1875)
Dardagny, probably 1853
Oil on canvas, 26.0 × 47.0 cm
Presented by William Edward Brandt, Henry Augustus Brandt, Walter Augustus Brandt and Alice Mary Bleecker in memory of Rudolph Ernst Brandt, 1963

Dardagny is a village in Switzerland about 10 miles west of Geneva. Corot visited Switzerland on a number of occasions in the 1850s, returning to Dardagny itself for a last time in 1863. This view probably dates from 1853 when, accompanied by Daubigny, Corot visited the artist Armand Leleux and his parents-in-law who lived in the village. Corot's friend and biographer Alfred Robaut writes that Corot painted this scene in the company of these two artists.

The blue hills to the left are the Jura. It is high summer and the fields on either side of the road are full of ripe corn. In this luminous view Corot has used a subtle colour scheme in which the harmonious shades of blue in hills and sky contrast with the yellow of the cornfields. The brushwork is restrained, with an even layer of paint over thin underpainting which shows through in many areas.

SH

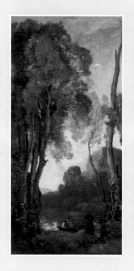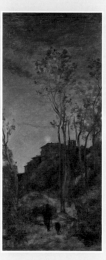

Jean-Baptiste-Camille COROT (1796–1875)
The Four Times of Day, about 1858

19 *Morning*
Oil on wood, 142.2 x 72.3 cm

20 *Noon*
Oil on wood, 142.2 x 62.2 cm

21 *Evening*
Oil on wood, 142.2 x 72.3 cm

22 *Night*
Oil on wood, 142.2 x 64.7 cm
On loan from the Loyd Collection

Corot painted these panels for the studio of the artist Alexandre Gabriel Decamps's new house in Fontainebleau, where he moved shortly before his death in 1860. Corot painted them extremely rapidly, completing all four in a week, and later related how Decamps exhorted him not to work so quickly, assuring him that 'there is still enough soup for a few days more'.

The speed with which the panels were painted is evident in the sketchy and thin paint in which all the brush strokes are visible. The imaginary compositions are imbued with the artist's reminiscences of his visits to Italy. In each panel the distant vistas are framed on each side by tall trees and one of the figures wears a red cap, Corot's habitual device for adding a foil to the prevailing green of the landscape. After Decamps's death the panels were the prized possession of another artist, Frederic, Lord Leighton.

SH

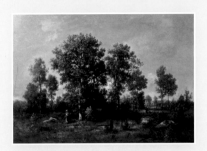

23 Narcisse-Virgilio DIAZ DE LA PEÑA (1807–1876)
Sunny Days in the Forest, probably 1850–60
Oil on canvas, 39.0 x 56.2 cm
Presented by Charles Hartree, 1906

This composition of a grove of trees shows the strong influence of Théodore Rousseau. Diaz first visited the village of Barbizon in the Forest of Fontainebleau in 1835, and on his return the following year he accompanied Rousseau on his sketching trips.

The bright blue of the sky and the fresh greens of the foliage evoke a spring day. The trees are built up from dark to light, giving depth and three-dimensionality. The detail with which the leaves are rendered in the foremost trees is also reminiscent of Rousseau. The foliage is picked out in very light touches of greens, beiges and creams, giving an effect of dancing light. The two women gathering sticks are probably added for decorative effect and the bright accents of red shawl and white headscarf, like the red caps of Corot's boatmen and herdsmen, add notes of colour to the landscape.

SH

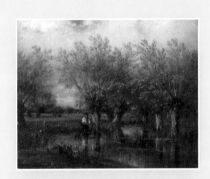

24 Jules-Louis DUPRÉ (1811–1889)
Willows, with a Man fishing, probably before 1867
Oil on canvas, 21.7 x 27.1 cm
Salting Bequest, 1910

This intimate scene of a man fishing at a pond bordered by a cluster of willows is typical of work by Dupré, who took delight in the juxtaposition of trees and water. The brushwork is varied; the whole is very thickly painted, with the trunks of the trees rendered in thick impasto, while the clouds are brushed in long thick strokes over the blue. By contrast in certain areas, such as the branches of the trees, the pale ground can be seen through the paint layers. Dupré has added further branches over the sky, rendering the delicate grey-green leaves of the willows in small feathery strokes.

The whole of this secret glade sparkles with highlights. In 1834 Dupré was among the first French landscape painters to visit England, and his use of tiny touches of light paint shows the influence of English painters, especially Constable, whose work he encountered during the trip.

SH

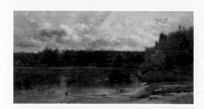

25 Charles-François DAUBIGNY (1817–1878)
River Scene with Ducks, 1859
Oil on oak panel, 20.4 x 40.0 cm
Salting Bequest, 1910

The river shown is the Oise near Auvers. Daubigny first visited Auvers-sur-Oise, where he was eventually to settle, in 1850. It was here that he acquired his floating studio, *Le Botin*, or 'Little Box' which is just visible moored on the right. Daubigny had this vessel, originally a ferry, converted into a sailing boat with oars. The cabin was turned into a studio and living quarters and painted in wide stripes of different colours. Daubigny used his boat to paint his tranquil river scenes and his example inspired Monet to acquire his own studio boat in 1872.

This quiet river view exhibits a great variation in the brushwork. While Daubigny painted the foliage in feathery strokes he used longer smooth strokes to portray the stillness of the water. The cloud-filled sky is painted with a multitude of swirling, curvilinear marks

 SH

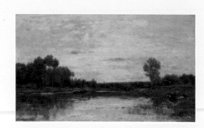

26 Charles-François DAUBIGNY (1817–1878)
View on the Oise, 1873
Oil on mahogany (?) panel, 38.8 x 67.0 cm
Bequeathed by Pandeli Ralli, 1928

To paint this serene rural view Daubigny was almost certainly sitting in his studio boat, *Le Botin*. The rows of water lilies growing out from the bank were a feature of the river Oise near Daubigny's house in Auvers, as described by a journalist at the time: '...great carpets of water lilies make the foreground to these ready-made pictures in front of which the painter has nothing to do but to sit down with his umbrella in the ground and his box of colours on his knees.'

On this occasion, perhaps back in the studio, Daubigny reworked his composition begun in the open air. The right bank of the river originally lay to the left of what we see now, and in latter stages of working Daubigny moved it, the tree and the washerwoman further to the right. Both the shapes of the first tree and the first washerwoman are visible through the paint layers.

 SH

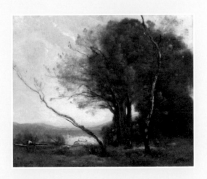

27 Jean-Baptiste-Camille COROT (1796–1875)
The Leaning Tree-Trunk, about 1860–5
Oil on canvas, 49.7 x 60.7 cm
Salting Bequest, 1910

The right side of the composition is dominated by a dense mass of foliage and the gnarled trunk of a tree. In the foreground stand two trunks, one arching gracefully across the picture, while in the background a lake is surrounded by misty hills. The device of leaning branches is shared by a number of other paintings by Corot, notably his *Souvenir de Mortefontaine* (Paris, Musée du Louvre), exhibited at the Salon of 1864. The figures of the boatman and woman gathering twigs from the tree are also features common to many of these paintings.

The lake is based on that at Ville d'Avray and the tangle of branches is an echo of sketches made by Corot at Civita Castellana, north of Rome, during his first trip to Italy. The silvery tonality and misty atmosphere, however, mark this out as a studio composition or 'souvenir', a painting in which the artist has juxtaposed elements to create an imaginary landscape.

SH

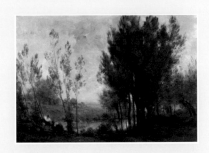

28 Charles-François DAUBIGNY (1817–1878)
Willows, 1872 or 1874
Oil on canvas, 55.5 x 80.3 cm
Salting Bequest, 1910

This is a late work, almost certainly a studio composition of an imaginary scene. The two figures probably derive from the washerwomen who appear in the artist's river scenes. In technique and appearance it is similar to Corot's late landscapes yet the coloration is bolder, particularly in the striking sunset at the centre. The sky is tinged pink at the horizon, and between the trees the fiery colours of the setting sun, from reds and pinks through to yellows and peaches, are reflected in the water.

Daubigny has painted with bold and free brushstrokes, sketching the trees initially in thin paint, and then painting the sky around them. They are then given body with further dabs of paint in various shades of greens to denote the foliage, in some cases with quite a dry brush, so that the texture of the thick swirling paint of the sky is visible through the leaves.

SH

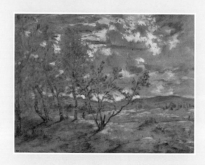

29 Théodore ROUSSEAU (1812–1867)
Landscape, about 1865
Black crayon and oil on millboard, 50.8 x 67.8 cm
Presented to the Tate Gallery by Mrs Julian Lousada, 1926; transferred 1956

A lone figure stands contemplating a chain of hills sketched in blue. The trunks of the trees throw long shadows, and the pink tinges to the clouds perhaps suggest a sunset. The application of paint is thin and the grey colour of the millboard support is visible in all areas, as is the artist's preliminary drawing in black crayon. The skeletal trees and cloud-filled sky lend an ethereal quality and silvery light to the landscape.

This is probably a scene in the Forest of Fontainebleau, but possibly painted in the studio. In later life Rousseau would often work from memory. He would also execute detailed drawings on canvas, which he would elaborate with paint. While the drawing plays a major part in this work it is sketchy and experimental and the whole is imbued with the strong sense of poetry which is a feature of the artist's late work.

SH

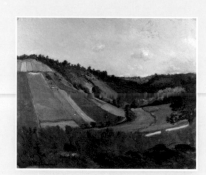

30 Philippe ROUSSEAU (1861–1887)
A Valley, about 1860
Oil on canvas, 81.0 x 99.7 cm
Presented by Francis Howard to the Tate Gallery, 1936; transferred 1956

Rousseau is best known now as a still-life painter, but all his early submissions to the Salon were landscapes. This view dates from later in his life, and its freely painted technique can be compared with that of the early Impressionists. The hillsides are divided into strips of small fields or kitchen gardens reminiscent of Pissarro's views around Pontoise of the same period, but Rousseau, while hinting at man's work, otherwise excludes human presence. The high horizon became a popular device later in the nineteenth century, but was also used by artists such as Millet and Théodore Rousseau, and by Corot in his views of the Morvan region.

The fresh cool tonality in the greens, achieved by adding a fair degree of white, and the broad fluid brushwork also demonstrate the artist's modern approach in his use of colour. The foreground undergrowth is extremely sketchily painted, the mid-brown ground showing through in many places.

SH

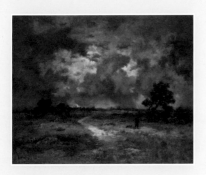

31 Narcisse-Virgilio DIAZ DE LA PEÑA (1807–1876)
The Storm, 1871
Oil on mahogany panel, 61.3 x 76.6 cm
Salting Bequest, 1910

The setting is the desolate heathlands near Barbizon. A path runs down the middle, to the right of which a lone huntsman carrying a gun is accompanied by two dogs, painted almost entirely in monochrome. The stormy sky breaks in the middle to show patches of blue and white clouds. This painting forms part of a group executed at the end of the artist's career, in which expressive brushwork and stormy skies evoke the struggle of man against the immensity of nature.

Diaz has painted the landscape in short, choppy, horizontal and diagonal strokes. The treatment of the sky, with multi-directional and expansive brushwork, echoes the stormy weather it describes. Where the sky meets the horizon, particularly in the centre of the picture, the brushwork is strongly vertical, and the artist has brought short strokes down over the tops of the bushes marking the extent of the landscape, perhaps to suggest rainfall.

SH

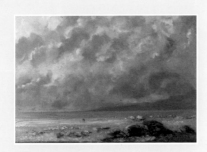

32 Gustave COURBET (1819–1877)
Beach Scene, 1874
Oil on canvas, 38.0 x 55.5 cm
Bequeathed by Sir Robert Hart, Bt, 1971

In 1871 Courbet was arrested and imprisoned for the part he played in the Paris Commune. In 1873 he was further ordered to pay the costs for the reconstruction of the Vendôme Column, for whose destruction Courbet was held responsible. Fearing bankruptcy, he passed into Switzerland secretly with his pupil Marcel Ordinaire and from October 1873 he settled at La Tour-de-Peilz on the shores of Lac Léman.

This is a view of the lake. On the rocky foreshore a woman bends in the water with a large basket on her back. On the far side of the lake the range of hills is shrouded in stormy clouds. As an afterthought, Courbet has added pink and peach streaks over the completed grey sky to denote a sunrise or sunset, also reflected in the water, and one of the three tiny boats is picked out in the same colour.

SH

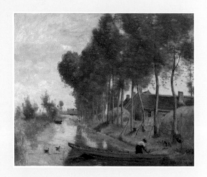

33 Jean-Baptiste-Camille COROT (1796–1875)
Landscape at Arleux-du-Nord, 1871–4
Oil on canvas, visible surface: 48.2 × 58.1 cm
Bequeathed by Helena and Kenneth Levy, 1990

During the Paris Commune of 1871 Corot's friend and biographer Alfred Robaut rented a cottage for the artist's use in the village of Arleux-du-Nord in northern France, where he painted a number of views. This is the second of two almost identical compositions by the artist. The first was based on a study by Robaut himself, but this work was painted at the actual site, and reworked in Corot's studio on 24 November 1874, just a couple of months before his death in February 1875. Its blond tonality recalls Corot's early work, but is also possibly a response to the light palettes of the Impressionists.

When Corot reworked the painting he completed the sky, which he always painted last. At the same time, he probably added the dancing highlights in the trees, details in the water, and a layer of pale blue-grey paint which partly obscures some of the reeds and ducks.

SH

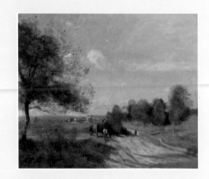

34 Jean-Baptiste-Camille COROT (1796–1875)
The Wagon ('Souvenir of Saintry'), 1874
Oil on canvas, 46.0 × 55.9 cm
Presented by William Edward Brandt, Henry Augustus Brandt, Walter Augustus Brandt and Alice Mary Bleecker in memory of Rudolph Ernst Brandt, 1963

Saintry is a village near Corbeil, south-east of Paris. While attending a family celebration there in May 1873 Corot painted a first version of this view, of which this painting is a repetition, or 'souvenir'. The road, bordered with a row of trees, leads off to Saintry in the distant left background. The whole picture is suffused with a sunny tonality and fresh atmosphere. Fresh light greens are used in the verges and trees and the row of trees on the right is painted in a myriad of strokes which creates a shimmering effect of light on foliage.

Corot's 'souvenirs' were usually meditations on nature painted in his signature misty and silvery coloration, perhaps from memory or based loosely on existing paintings. This view, while painted in the studio, is closely based on a real scene, and conveys a palpable sense of the atmosphere of a sunlit landscape.

SH

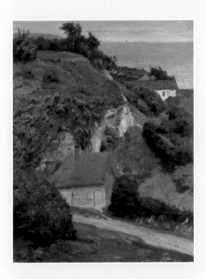

35 Antoine CHINTREUIL (1814–1873)
Houses on the Cliffs near Fécamp, probably 1861
Oil on paper mounted on canvas, 41.0 × 31.7 cm
Bought by the Tate Gallery, 1928; transferred 1956

Chintreuil was greatly influenced by Corot to paint in the open air. It was not until the end of his life, however, that he turned his attention to the sea, and in 1861 he visited the fishing town of Fécamp in Normandy. This part of the coast is noted for its high limestone cliffs, giving it the name of Côte d'Albâtre (Alabaster Coast). During his stay Chintreuil made a number of sketches in the open air. The paper used here, subsequently stuck down on canvas, has pin pricks in each corner, suggesting that it was among those painted on the spot.

The artist has chosen an unusual vertical format with a high horizon. Throughout, the brushwork is fluid and bold, with strokes following the contours of the land and horizontal strokes in the sea. Yet despite the broad brushwork the composition has an intimate air, and the houses nestling against the cliffs are depicted with precision.

SH

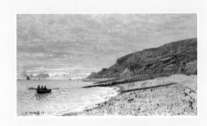

36 Claude-Oscar MONET (1840–1926)
La Pointe de la Hève, Sainte-Adresse, 1864
Oil on canvas, 41.0 × 73.0 cm
Bought, 1996

The beach of Sainte-Adresse lies just west of Le Havre on the Normandy coast. Monet arrived in nearby Honfleur in the last week of May 1864 with his fellow artist Frédéric Bazille and painted a group of plein-air pictures including a number which show, as here, the view across the breakwaters towards the headland of La Hève. At the Salon of 1865 Monet exhibited two paintings based on these studies, whose similar broad brushwork was ground-breaking in obscuring the divisions between studies and finished works.

Like the Barbizon artists, Monet was seeking to find the equivalent in paint for light and texture in nature. Here he has applied the thick white paint used to render the foam on the shingle beach with quite a dry brush, so that the grey stones are covered in a myriad tiny touches of white, an echo of the sea foam lingering on the pebbles.

SH

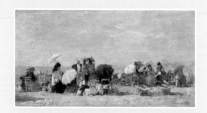

37 Eugène BOUDIN (1824–1898)
Beach Scene, Trouville, 1873
Oil on panel, 15.5 x 29.9 cm
Bequeathed by Miss Judith E. Wilson, 1960

Boudin was primarily a painter of the coast, and above all that of Normandy, where he had grown up. In 1862 he began to paint the fashionable holidaymakers who gathered each summer on Trouville beach. Never drawing too close, he often presented them as a frieze of figures strung out along the sand. Although they are engaged in conversation, we are not privy to what is being said; faces are expressionless, in some cases featureless. His feat was to integrate the crowds into the seascape, capturing not only the light and breezes of the sea but also their play on faces, hair and clothes.

Here the figures huddle in groups, sitting stiffly upright on the wooden chairs which were a feature of the beaches at that time, before the advent of the reclining deckchair. Two chairs have been blown over in the breeze, lending a note of informality to the scene.

SH

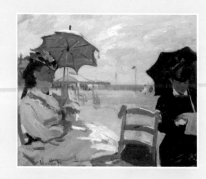

38 Claude-Oscar MONET (1840–1926)
The Beach at Trouville, 1870
Oil on canvas, 38.0 x 46.5 cm
Bought, 1924

On 28 June 1870 Monet married his partner Camille Doncieux in Paris, and they settled for the summer in the fashionable resort of Trouville. During their stay Monet painted a series of pictures in which he focused on women on the beach. Here it is Camille herself who sits dreamily under her parasol on the left, in a light grey and blue dress, while her older companion (perhaps the wife of the painter Eugène Boudin) sits further back in a dark dress, her eyes lowered to her book.

Monet's speed of painting and bravura handling of the paint mark out the series as seminal in open air painting. His extreme economy of strokes includes just one squiggle of paint to denote the ruff on Camille's dress. This work also literally bears the mark of the open air. The light sea breeze which agitates the flag also stirred up the sand and blew it into the wet paint as Monet worked.

SH

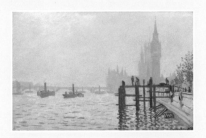

39 Claude-Oscar MONET (1840–1926)
The Thames below Westminster, about 1871
Oil on canvas, 47.0 x 73.0 cm
Bequeathed by Lord Astor of Hever, 1971

In 1870–1, fleeing from the Franco-Prussian War in France, Monet made his first visit to London. He found inspiration in both its parks and the River Thames, as in this view, where he is looking towards the recently completed Houses of Parliament and newly built iron Westminster Bridge. On the right men are dismantling a jetty which was probably used in the construction of the Victoria Embankment, created between 1864 and 1870.

Monet's view has a quiet grey stillness which belies the busy city scene it depicts. The restrained palette is also matched by his paint handling. The light ground shows through the thinly worked sky, and on the left the bridge is visible through the transparent paint of the boats.

Monet was notorious for adding dates to his pictures many years later, and here his date of 1871 is in a different colour from the signature. In fact it is possible that he painted it a year earlier.

SH

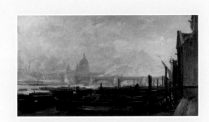

40 Charles-François DAUBIGNY (1817–1878)
St Paul's from the Surrey Side, 1871–3
Oil on canvas, 44.5 x 81.0 cm
Presented by friends of Mr. J.C.J. Drucker, 1912

Like Monet, Daubigny took refuge from the Franco-Prussian War in London, where he also found inspiration in the bustling river. This view looks north-east towards St Paul's Cathedral. Blackfriars Bridge spans the river, behind which a train, invisible apart from its plume of smoke, crosses Blackfriars Railway Bridge. At the far left can be seen the gasometers of the City of London Gasworks, which were removed at the end of the 1870s.

The artist has painted an industrial, modern city in which the pervading atmosphere is of smoke, from the chimneys, the train and the paddle steamers. The leaden sky is heavily painted in creams, beiges, greys and dirty pinks. In fact the fog and clouds were added at a later stage, almost certainly when Daubigny was back in Paris. He had signed the picture in black, but added the date of 1873 in blue when he reworked it.

SH

COROT TO MONET is one in a series of books focusing on highlights of the National Gallery Collection.

Other titles in the series include:

MANET TO PICASSO

Christopher Riopelle,
with Charlotte Appleyard,
Sarah Herring, Nancy Ireson
and Anne Robbins

ISBN 978 1 85709 333 9

DUTCH PAINTING

Marjorie E. Wieseman,
with Elena J. Greer

ISBN 978 1 85709 358 2

DUCCIO TO LEONARDO

ITALIAN PAINTING 1250–1500

Simona Di Nepi

ISBN 978 1 85709 421 3

EL GRECO TO GOYA

SPANISH PAINTING

Dawson W. Carr

ISBN 978 1 85709 460 2

National Gallery publications generate valuable revenue for the Gallery, to ensure that future generations are able to enjoy the paintings as we do today.

Visit www.nationalgallery.org.uk